TIS THE SEASON
New York

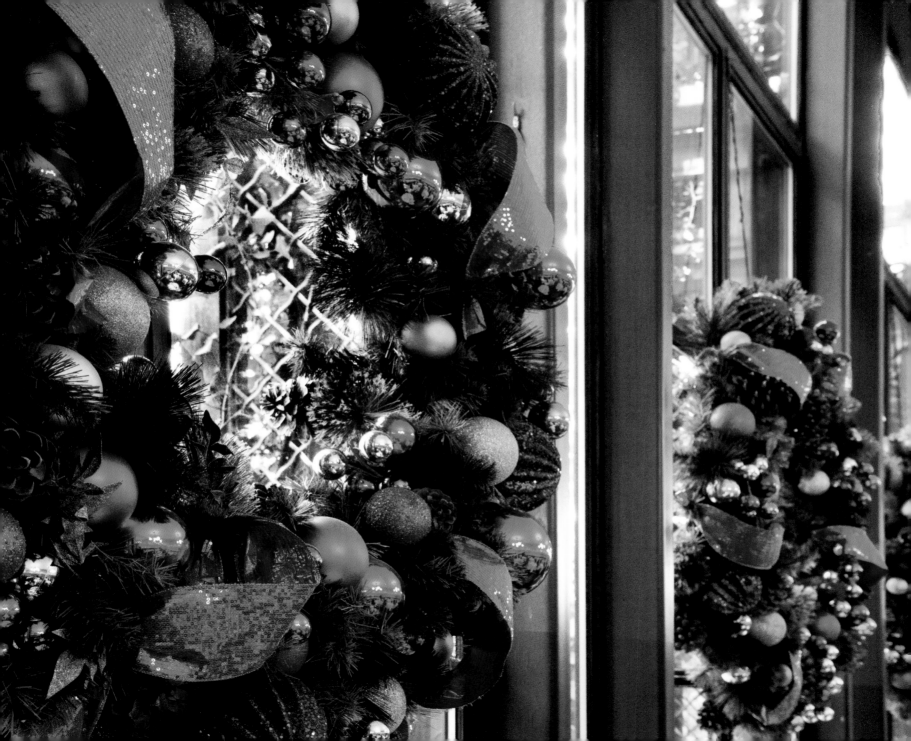

Tis the Season

NEW YORK

Betsy Pinover Schiff

Schiffer Publishing Ltd

4880 Lower Valley Road • Atglen, PA 19310

Copyright © 2018 by Betsy Pinover Schiff
Library of Congress Control Number: 2018934611

Cover design by Brenda McCallum
Type set in Bodoni SvtyTwo ITC TT/Lato
ISBN: 978-0-7643-5604-9
Printed in the United States of America

Published by Schiffer Publishing, Ltd.
4880 Lower Valley Road
Atglen, PA 19310
Phone: (610) 593-1777; Fax: (610) 593-2002
E-mail: Info@schifferbooks.com
Web: www.schifferbooks.com

Other Schiffer Books by Betsy Pinover Schiff:

Windows on Central Park: The Landscape Revealed, ISBN: 978-0-7643-3835-9

Other Schiffer Books on Related Subjects:

Archipelago New York by Thomas Halaczinsky, ISBN: 978-0-7643-5507-3

Christmas at Designers' Homes Across America by Katharine Kaye McMillan & Patricia Hart McMillan, ISBN: 978-0-7643-5163-1

Vista Manhattan: Views from New York City's Finest Residences by Mike Tauber, ISBN: 978-0-7643-5148-8

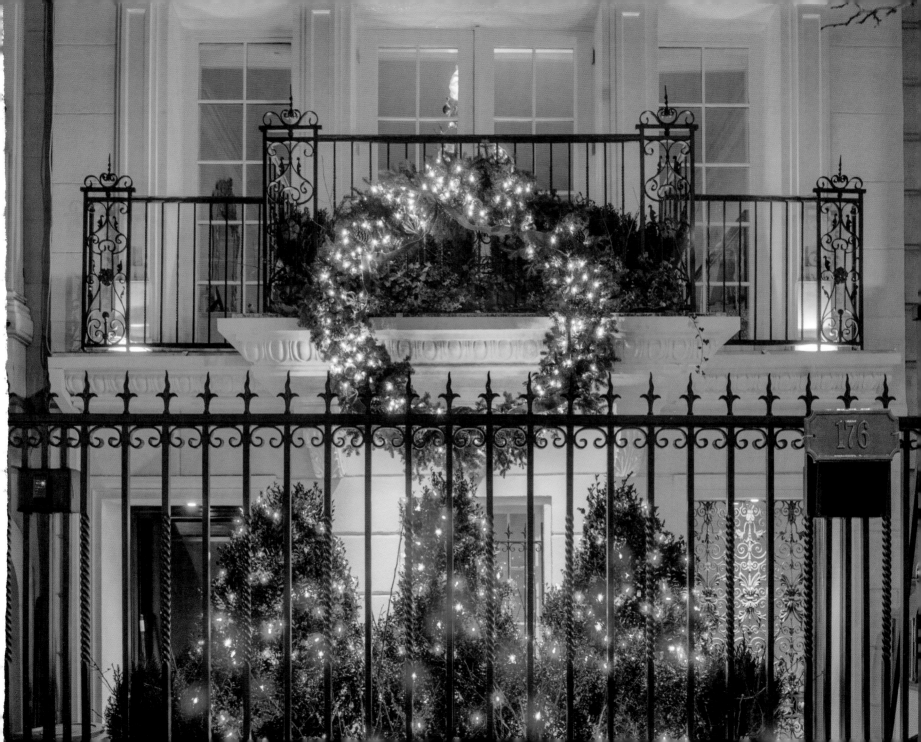

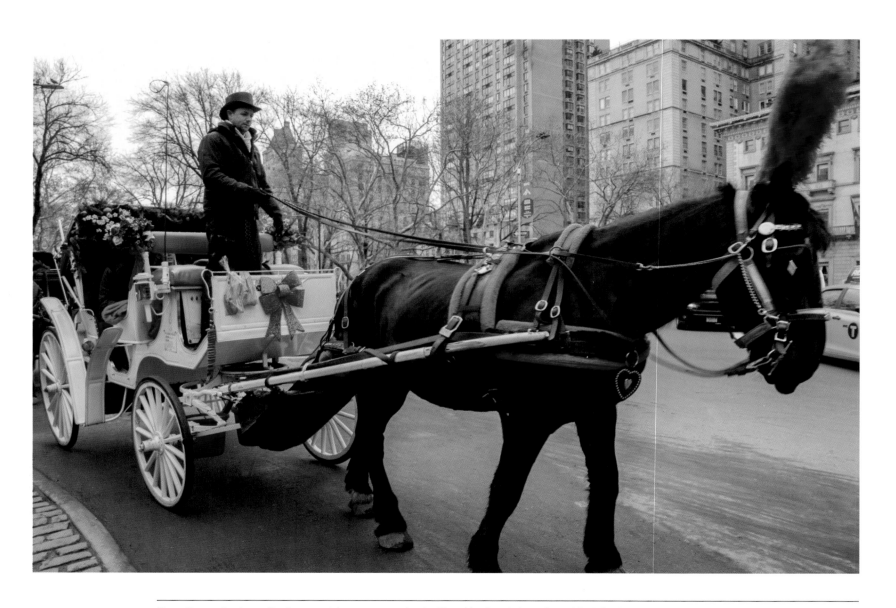

Horse-Drawn Carriage. Carriages wait for passengers by the Plaza Hotel and along Central Park South. A carriage ride is a memorable way to experience the beauty of Central Park, even in the cold of winter.

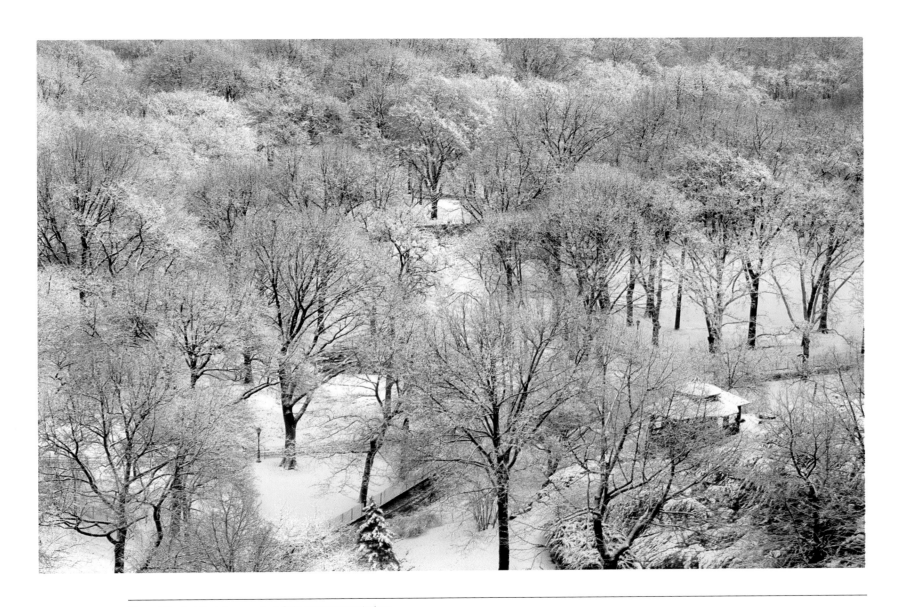

View of Central Park from an East Side apartment window.

Foreword

James Barron, *New York Times* reporter and Metro columnist.

At a party celebrating her last book, Betsy Pinover Schiff asked, offhandedly, if I knew someone who could write the introduction to her next book — this one. She said it was going to be a book about New York City at Christmastime. I said I was singularly well qualified for the job because I was born on Christmas Day.

That has made me finicky about Christmas — I consider the holidays my own personal season — but happily, unsurprisingly, Betsy has given us a view of the holidays in New York City that is inspired and inspiring. She shows us the macro view — buildings that become ornaments with bright bows and ribbons tied up at street level, where even nose-in-their-cellphone pedestrians will notice. She gives us the micro view, too — the skyline-in-a-paperweight look that is embellished by the department store windows. Even the streets look seasonal, with the red of the cars' brake lights and the green of the traffic signals. And there are houses draped in Christmas lights, so many that you wonder about the owners' Con Ed bills.

The scenes she found are antidotes to the urban headaches of the other eleven months of the year. Amid the usual holiday suspects — pot-bellied Santas, galloping reindeer, and snowmen who never melt — she reminds us that this is the time of year when the crowds are part of the show. We shoppers swarm from store to store, defying the experts who insist that we are all shopping online. Jostling toward the tree in Rockefeller Center, we realize that Christmas in New York is a spectator sport. With the tree come the skaters, circling, trying figure-eights, tumbling, laughing, getting up, and trying again. That's not the only place where Christmas becomes a participatory sport. There are performances of Handel's "Messiah" at which the entire audience is the chorus.

There is history here — literally, because by some accounts New York invented the way America imagines Christmas. Stiff- and starched-looking Washington Irving gave us more than the headless horseman of Sleepy Hollow and Rip Van Winkle: he gave us the beginnings of the Santa Claus we know. He wrote an 1809 satire that poked fun at the Dutch who originally controlled New York with characters like William the Testy (a stand-in for Thomas Jefferson) and Peter the Headstrong (a less oblique reference to Peter Stuyvesant, the Dutch governor who lost New Amsterdam to the British, who renamed the young city New York).

Irving's St. Nicholas was a carved figure on a ship bound for whatever name you prefer for the town so nice they eventually named it twice. Irving's readers would have recognized Nicholas as the patron saint of Christmas, but they might not have recognized his St. Nicholas, who had an unsaintly pipe and a broad-brimmed hat.

Thus began the transformation of a Dutch saint into an American icon. Not quite fifteen years later, a poem was published that was widely attributed to Clement Clarke Moore, who not only taught at the General Theological Seminary, he donated his apple orchard on Ninth Avenue as its campus. The poem had the lines we all know, right from the beginning: "'Twas the night before Christmas." The central character was "a right jolly old elf." "His eyes — how they twinkled! His dimples how merry! His cheeks were like roses, his nose like a cherry!" And "the beard of his chin was as white as the snow."

Santa's makeover was completed by another New Yorker, the cartoonist Thomas Nast, who also gave the Democrats the donkey and the Republicans the elephant. Nast put Santa in a red suit and a stocking cap. Nast's Santa also piled on the pounds, making chimneys a challenge.

Against that historical backdrop, Betsy sees my own personal season as it should be seen. She captures it the way she captured the city's gardens in her earlier books, with an eye that prizes the formality of one holiday scene and the fantasy of another. She catches the hard, linear edges of Manhattan streets softening as they do when stars dangle from the lampposts and decorations that appear on holiday trees sprout in the plazas. She befriends the lacquered nutcrackers and dancing sugar plums. She circumnavigates Manhattan on tour boats retrofitted with garlands that flutter in the chilly winter wind.

It's a magical tour of a magical place at a magical time, and as the self-appointed arbiter of my own personal season, I approve. But I think you will, too.

Author's Preface

At the start of the Christmas holiday in 2016, I walked through Central Park to the Winter's Eve Festival, wandering from the tree lighting across from Lincoln Center to the dazzling Holiday Light Show at the Time Warner Center. I followed a puppet procession, watched an ice carver at work, and marveled at characters on stilts. I enjoyed a tasty lamb brochette from one of many street vendors while listening to a jazz group.

The unexpected fun and excitement of that evening inspired an exploration on foot with my camera, often three and four hours a night, that took me uptown to Harlem and downtown to the 9/11 Memorial, as well as to the boroughs beyond. Illuminated office towers loomed like fantasy works of art. Department store and boutique windows, the plazas of office buildings, and the front yards of private houses were more elaborately decorated than ever. Carol singers and holiday markets seemed to be everywhere. To capture new perspectives, I boarded a Christmas harbor cruise boat and hopped on the upper deck of a Big Apple tour bus. I photographed church choirs and pageants, observed the Jewish Festival of lights, and participated in the Latin American Dia de los Reyes. Each night was an adventure. Everywhere I went, the talent and creative spirit of New Yorkers was evident, even in the most unexpected of places.

It became clear that New York merited a book to communicate the fun, fantasy, and endless heartwarming moments in the city at Christmastime. While the photographs in this book tell my own story, the quotes, interspersed among them, tell the story of others who offered their personal memories or experiences at Christmas.

I invite you along on my journey. It's my hope that this book will inspire you and others to see New York in a new way, to embrace its Christmastime offerings, and build your own memories of magic.

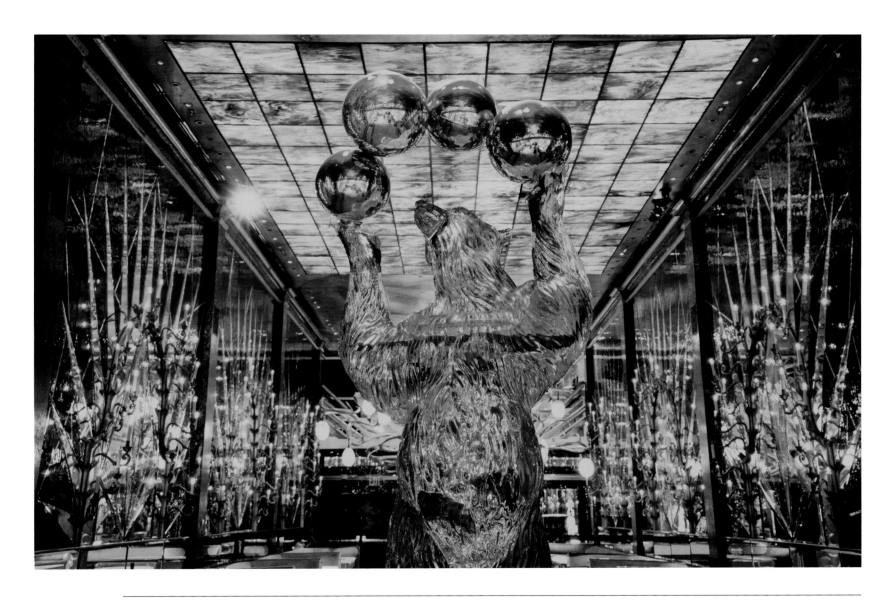

Russian Tea Room. A fifteen-foot revolving bear stands in the grand second-floor ballroom of the celebrated restaurant on 57th Street with walls of glass and stained-glass ceilings. The restaurant was designed and decorated in the modernist Russian style by Warner Leroy, who envisioned restaurants as dazzling stage sets with elaborate food presentations and tea poured from antique samovars.

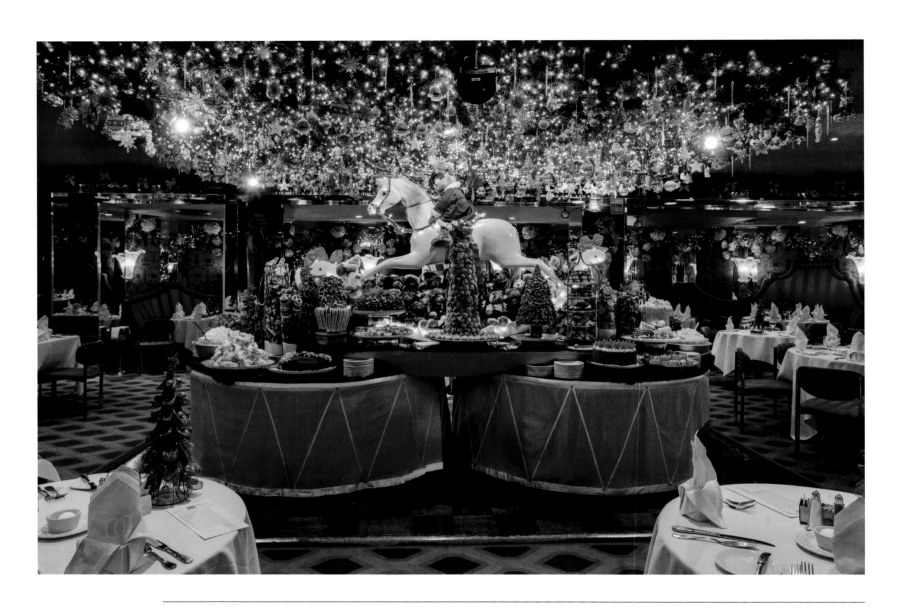

Doubles. Christmas luncheons are elaborately decorated at this private club in the Sherry Netherland Hotel on Fifth Avenue, founded in 1976.

"I love Christmastime in New York because it takes us way beyond the usual. Christmas is joy and light; it inspires our senses and our understandings in the way a painting does. Christmas is a form of art, and a gift – as all art is.

I believe that art exists in every day, that we draw the sustenance of art from the busy streetscapes and park settings we see everywhere, from store windows and river views, billboards and marquees – from all the many sights of our hours. The Christmas season is the masterpiece of all the art around us. Each tree on the sidewalk has a story as it gets carried home for Christmas. Store fronts and facades shine with wreaths, candy canes, and toy soldiers; windows sparkle; bells and choristers resound. Christmas markets in the parks want our applause, and every door wants opening, like a well-wrapped gift.

At Christmas, we make the usual unforgettable. If a walk is colorful, instructive, and artful, then Christmas is a walk in wonderland. It is the masterwork, the brightest and the biggest exhibition, the gift we all get."

Agnes Gund
President emerita the Museum of Modern Art; Founder, Studio in a School

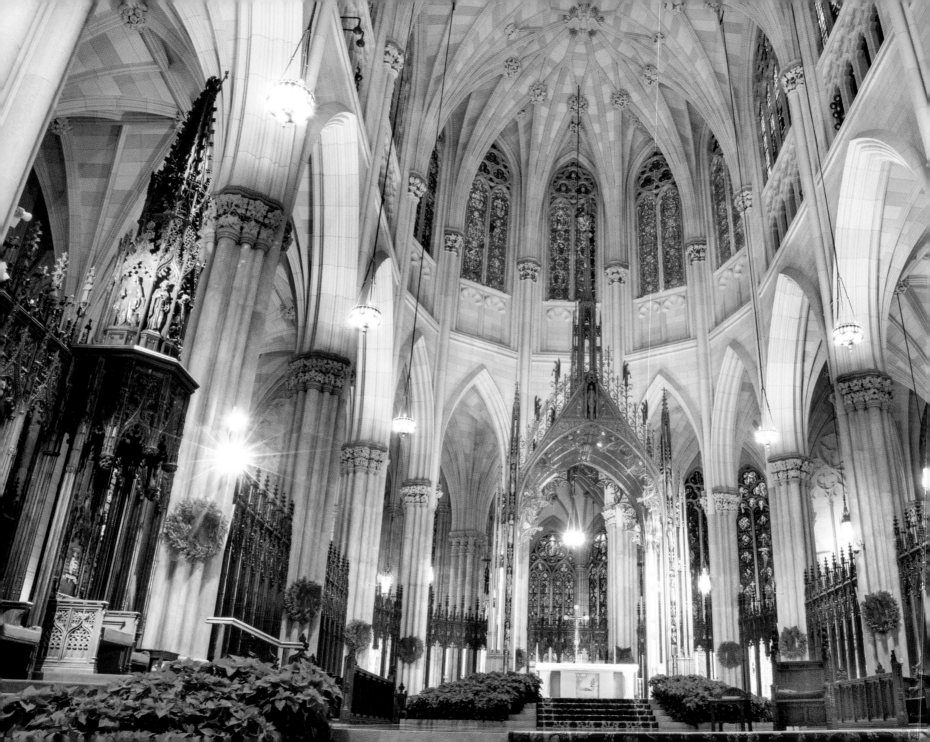

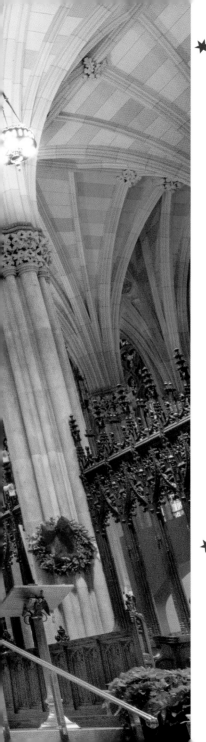

Saint Patrick's Cathedral. The Fifth Avenue cathedral across from Rockefeller Center is considered a masterpiece of nineteenth-century Gothic Revival architecture. It holds special choir and organ concerts and Christmas masses over the holidays, when it is decorated with poinsettias. Designed by James Renwick Jr., and opened in 1879, St. Patrick's is the seat of the archbishop of the Roman Catholic Archdiocese of New York, visited annually by more than five million people of every nationality and faith.

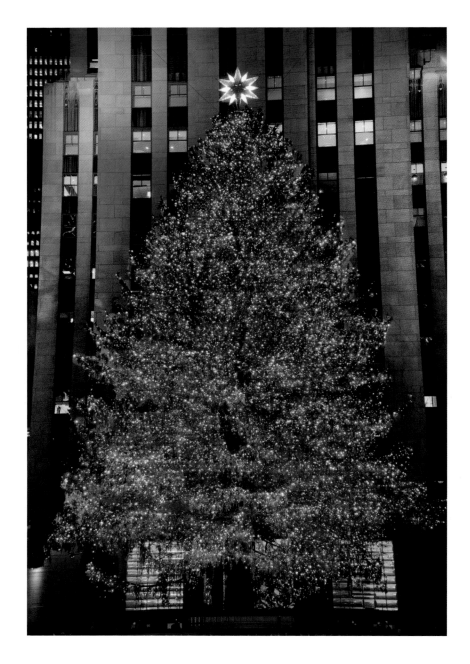

Rockefeller Center Tree. The carefully selected Norway spruce tree is topped by a crystal star and hung with 50,000 colored LED lights. Thousands crowd the sidewalks and millions more watch the live broadcast of the annual Tree Lighting Ceremony, a tradition for more than seventy-five years.

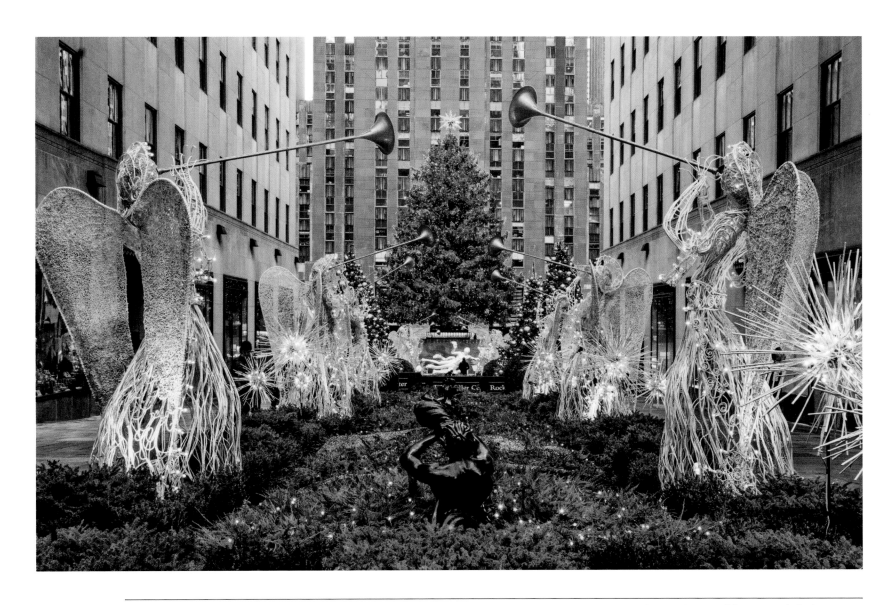

Rockefeller Center Promenade. The Christmas Angels in the Channel Gardens along the 200-foot promenade are the most famous of the seasonal displays at Rockefeller Center. Each of twelve illuminated wire angels holds six-foot-long brass trumpets angled toward the world-famous Christmas tree, and glitter with thousands of tiny lights.

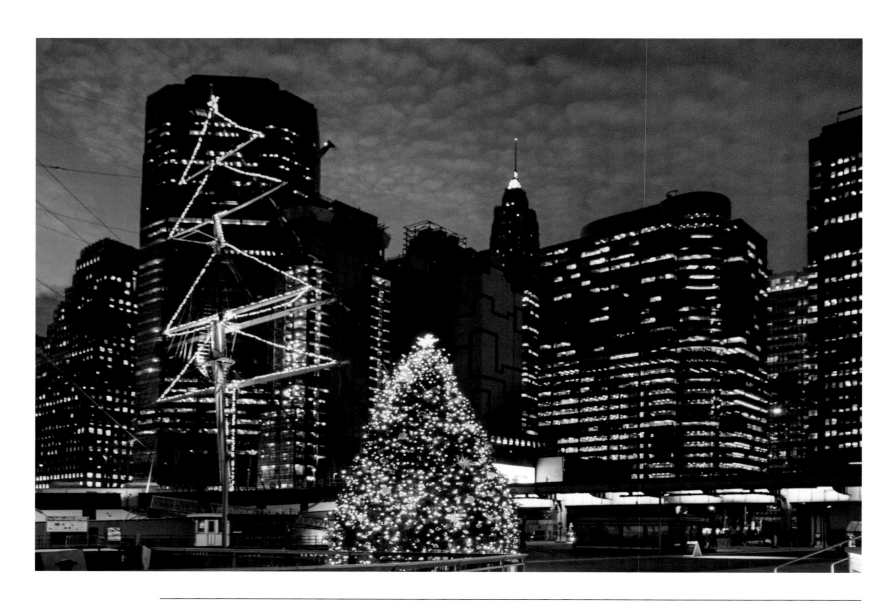

South Street Seaport. Viewed from the wharf, the lit sails of the historic Wavertree cargo ship stand out against the seaport skyline.

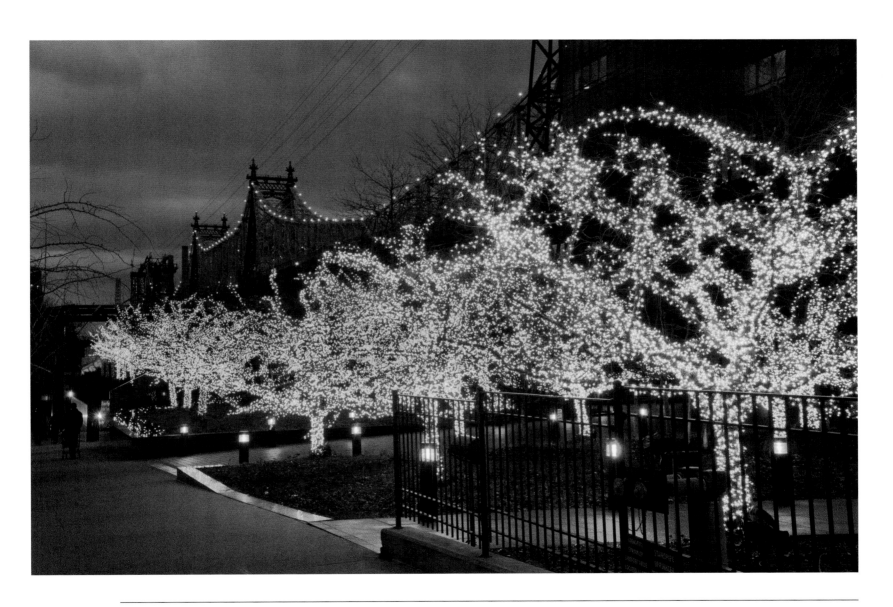

Illuminated street trees. Trees are increasingly wrapped with lights along city streets, viewed here in the East 60s with the Ed Koch Queensboro Bridge behind.

Bloomingdales. Both the Third Avenue and Lexington Avenue sides of the flagship store at 59th Street glow with alternating red and green window lights.

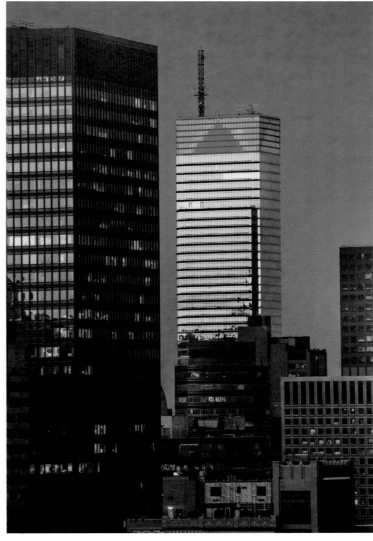

7 Bryant Park. The thirty-story glass and steel office tower on Sixth Avenue has an eye-catching pair of cones incised out of a corner that diagonally faces the park from across the street. The LED lights in the cones turn red and green at winter holiday time, outlining a kind of mirrored Christmas tree.

Bloomberg Tower. Viewed from a penthouse thirty blocks south, the top three floors of the fifty-five-story building at 731 Lexington Avenue glow red and green at Christmastime.

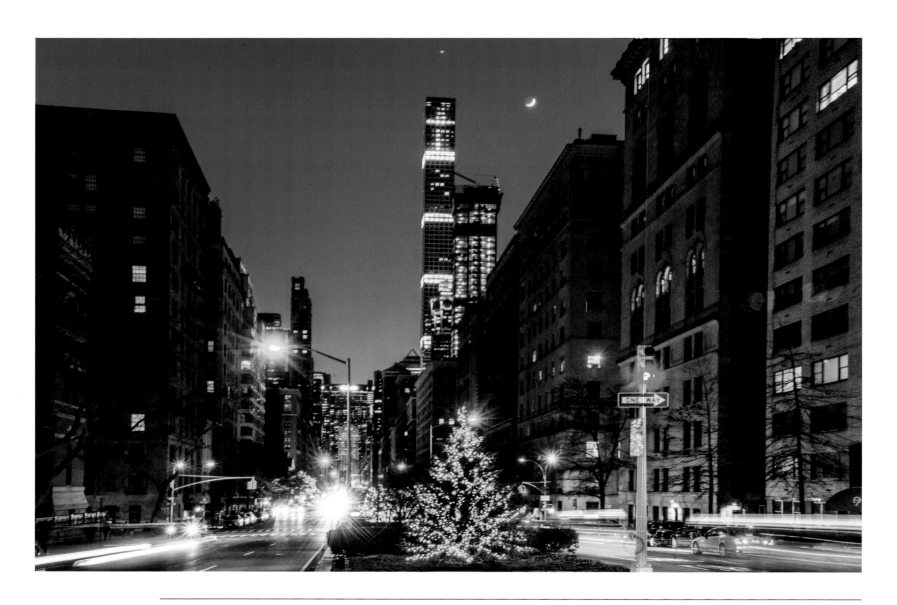

A view down Park Avenue from the East 60s with the tall 432 Park Avenue building in the distance.

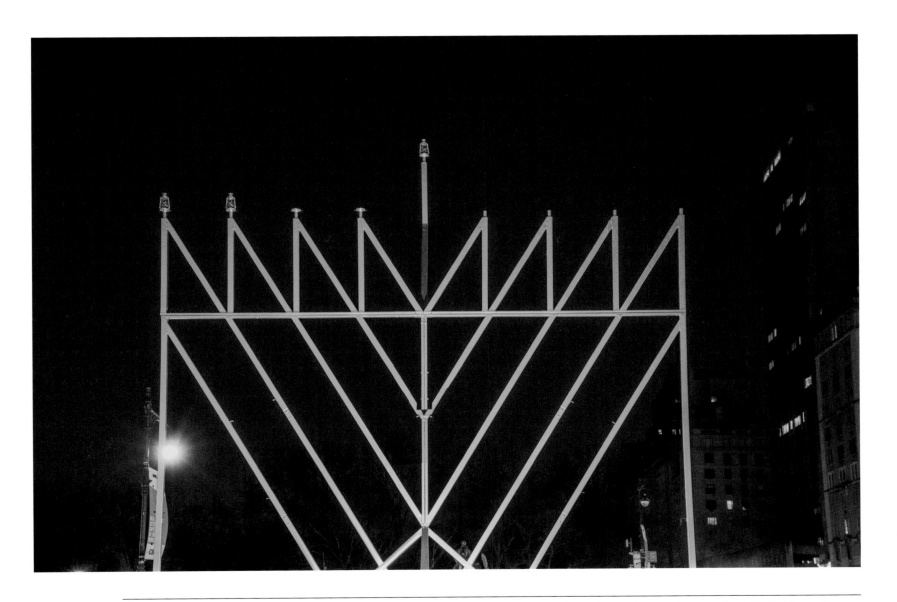

The Menorah. A symbol of Judaism since ancient times, the menorah is lit on each of the eight nights of Chanukah, the Jewish festival of lights, that frequently coincides with Christmastime. The thirty-two-foot-high steel menorah, weighing 4,000 pounds, is considered the largest in the world. It stands at Fifth Avenue and 59th Street. An equally large one of different design is lit at Grand Army Plaza in Brooklyn.

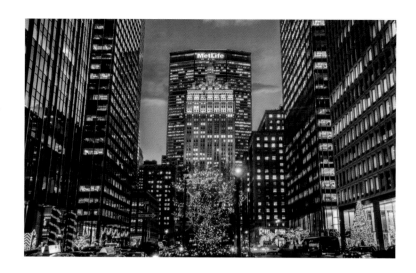

66 The best thing to do in New York at Christmas is to walk toward the holiday
lights, which means walking almost anywhere: along Park Avenue, which
becomes a boulevard of sparkling white light; along Fifth Avenue, where the
store windows are tableaux of enticement; in Rockefeller Center, where the tree
is ground zero of Christmas in New York. But every neighborhood, every street,
every plaza has something at this season that makes it glow, and that makes
walking around the city at holiday time even more rewarding than usual. 99

Paul Goldberger
Pulitzer Prize-winning architectural critic and writer

Park Avenue. In midtown, the broad avenue is distinguished by many glass skyscrapers that serve as headquarters for corporations and investment banks, with the MetLife building at center.

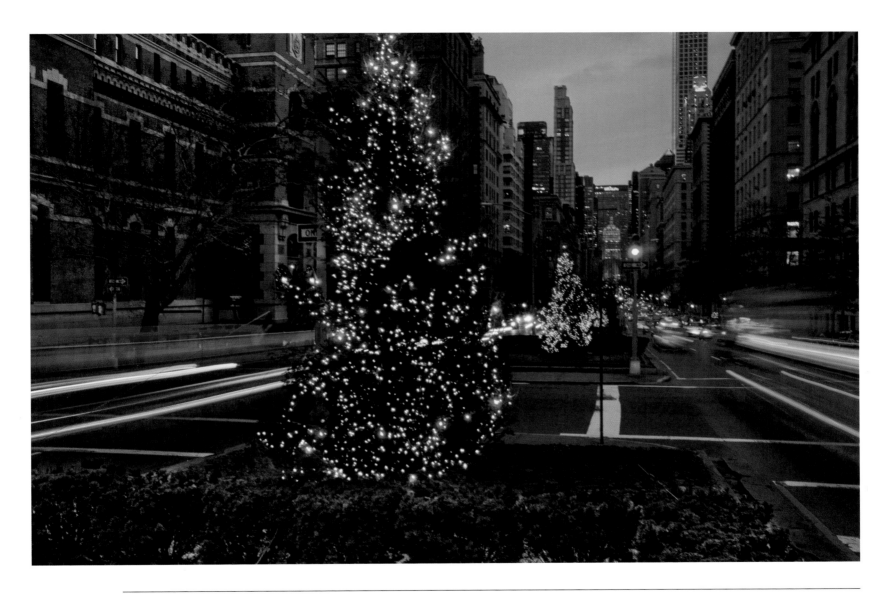

Park Avenue Christmas trees. More than one hundred fir trees between 54th and 97th Streets on Park Avenue are planted and illuminated by the Fund for Park Avenue. The tradition began in 1945, as a memorial to Americans who died in WWII and in celebration of New York's holiday season.

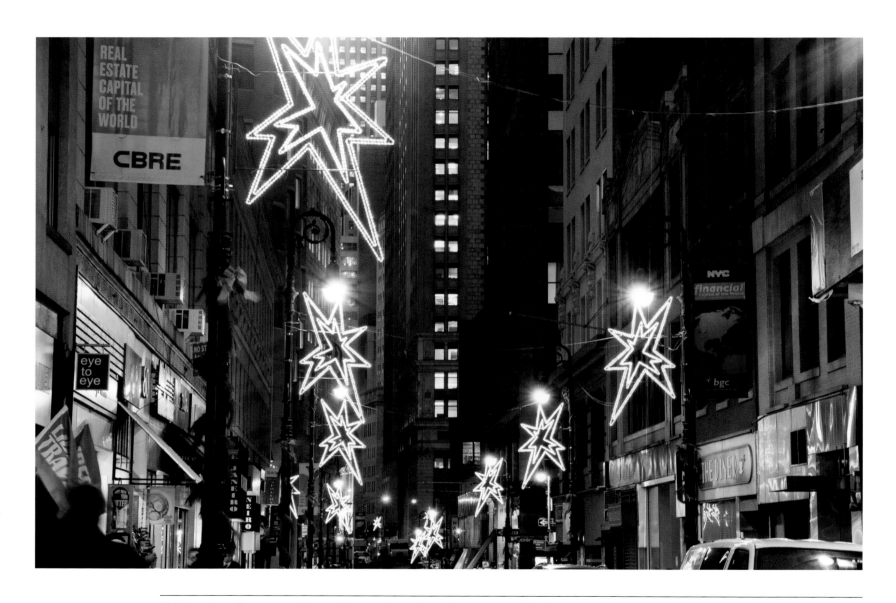

Christmas stars. Stars are popular over-the-street decorations and are seen in all the boroughs of New York at Christmastime, like the one that crosses West 82nd Street or those on Nassau Street in the Financial District.

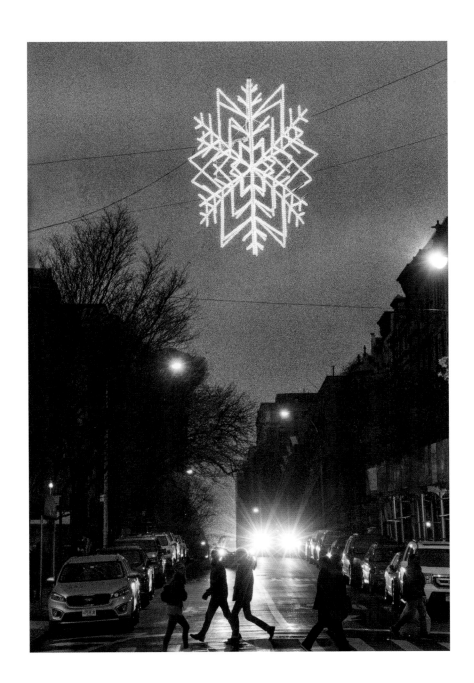

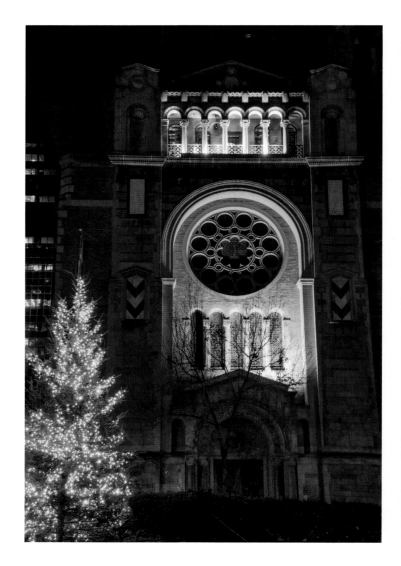

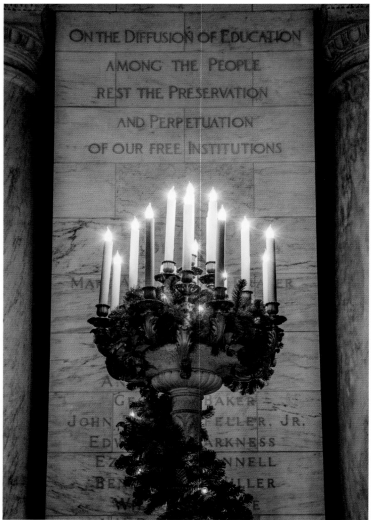

ON THE DIFFUSION OF EDUCATION
AMONG THE PEOPLE
REST THE PRESERVATION
AND PERPETUATION
OF OUR FREE INSTITUTIONS

Christ Church. Soft night lighting accentuates the well-proportioned exterior of the church on Park Avenue at 60th Street, dating from 1931.

New York Public Library. One of two illuminated candelabra, with acanthus-embellished bronze arms, stands in front of an inscribed marble pier in Astor Hall, the grand entranceway to the library's Stephen A. Schwarzman Building at Fifth Avenue and 42nd Street.

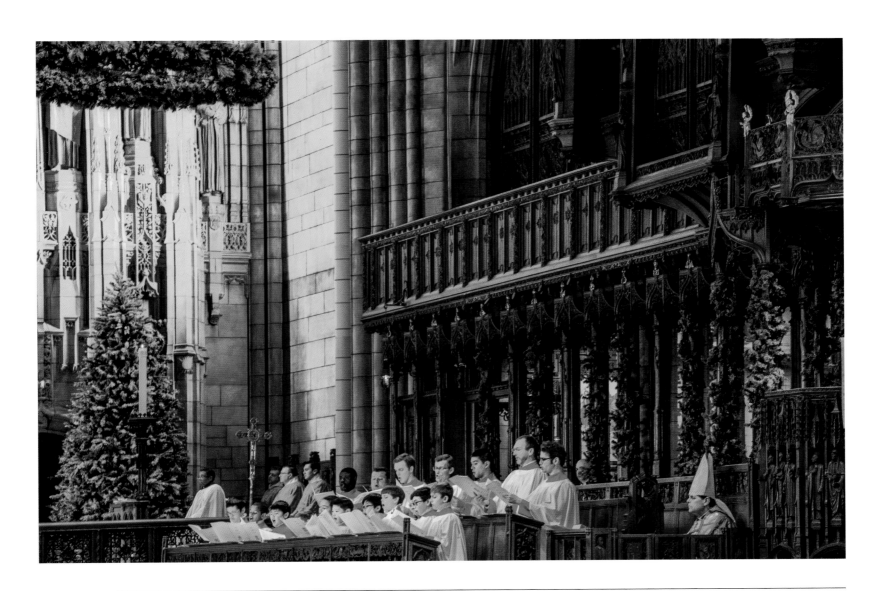

Saint Thomas Church. Music has long been an important component of worship and liturgy at Saint Thomas Church on Fifth Avenue at 53rd Street. Its lauded Choir of Men and Boys offers concerts of Christmas carols and Handel's "Messiah" in December, and the choir also sings at nearly 200 worship services throughout the year. Built in 1913, the Gothic-style landmark is also known for its organ recitals, concerts, choir school, and thirty-two-foot-high Gothic Revival stained-glass windows that celebrate the glory of sacred music.

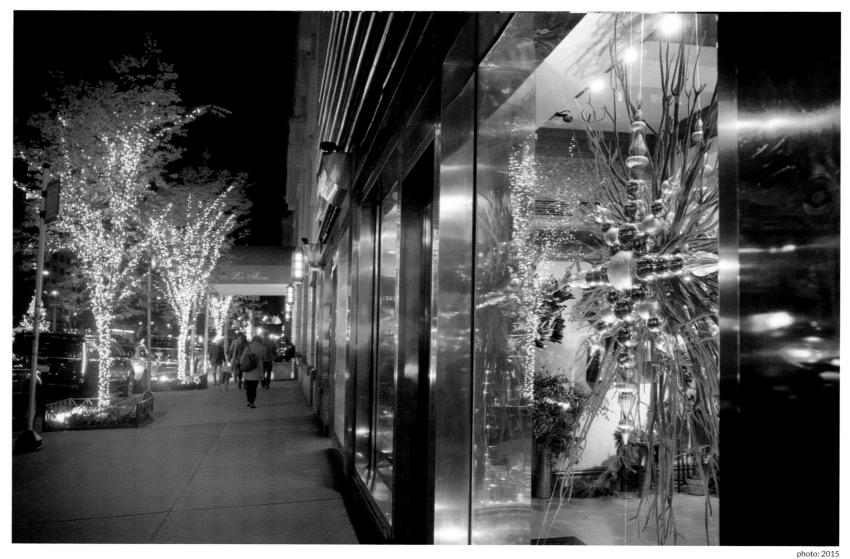

photo: 2015

Renny & Reed. As one looks uptown on Park Avenue, the striking shop window at right is adorned with vibrant red branches and silver ornaments. Famous for its floral and event designs, the firm was founded by Renny Reynolds in 1972.

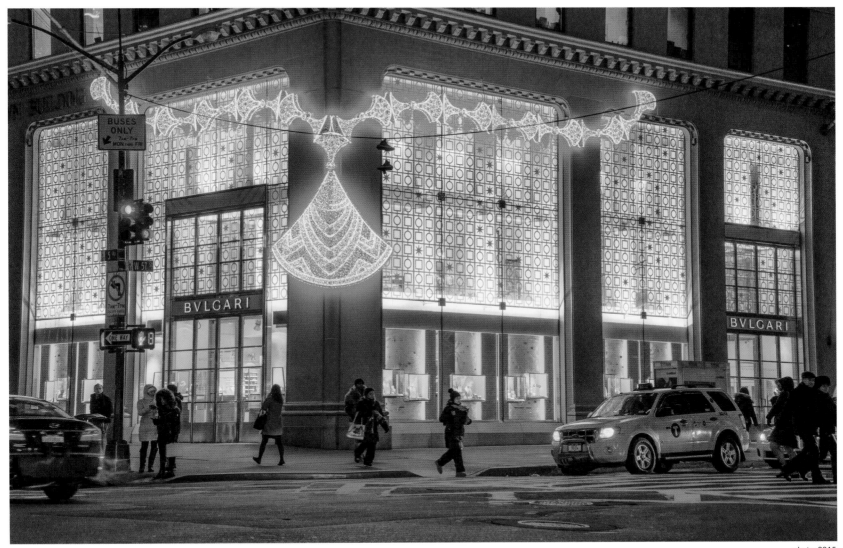

Bulgari. The glittering necklace from the emblematic, snake-themed Serpenti Collection is shown wrapped around the corner of the Crown Building that houses the flagship New York store of the Italian jeweler at Fifth Avenue at 57th Street. The store was dramatically redesigned by Peter Marino in 2017. Founded in Rome in 1884, Bulgari is noted for its distinctive and luxurious designs for jewelry and watches.

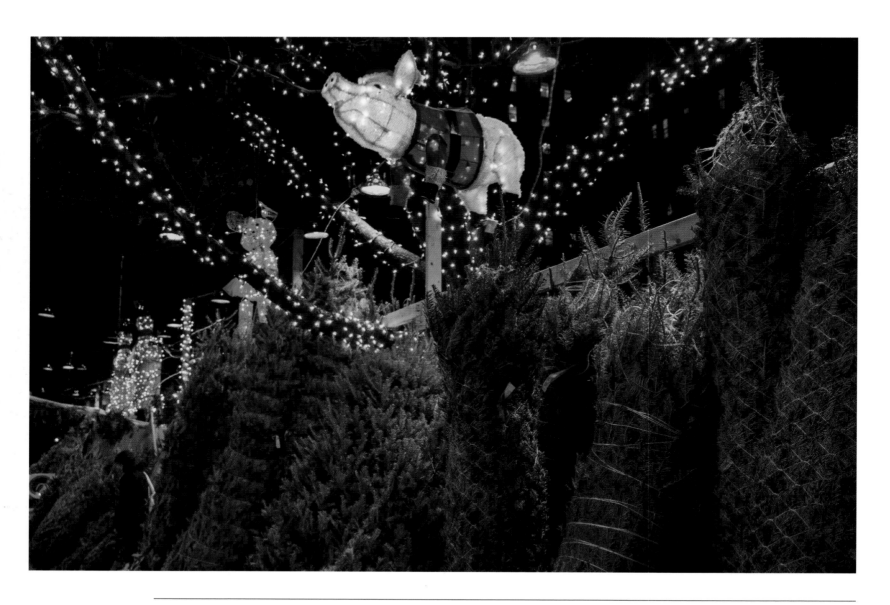

Christmas tree vendors. Hundreds of vendors flock from as far away as Quebec to sell trees on New York sidewalks, like this vendor on Broadway on the Upper West Side. Many corner markets add fir trees to their usual fare of evergreen and flowering plants of the season.

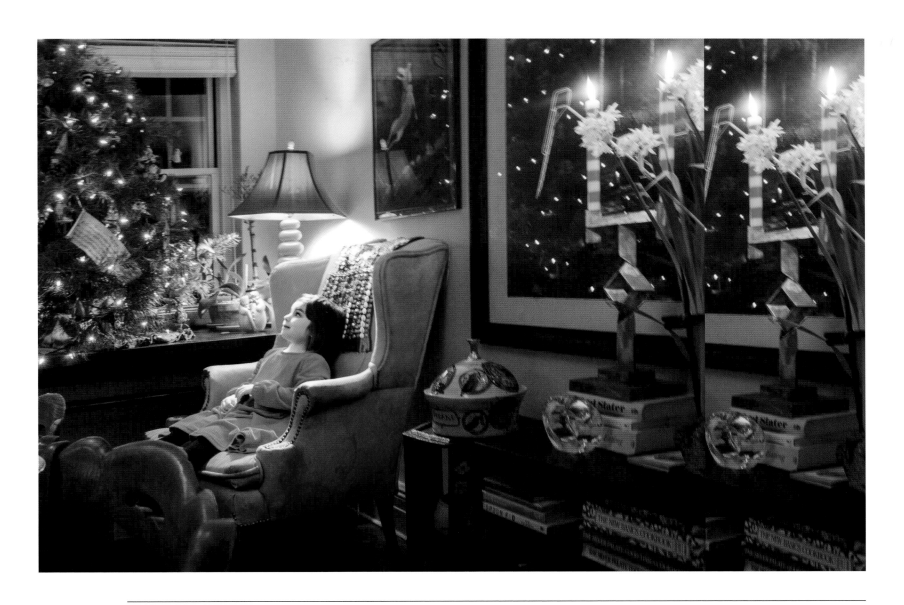

A child sits in awe of the Christmas tree in a private Upper West Side apartment.

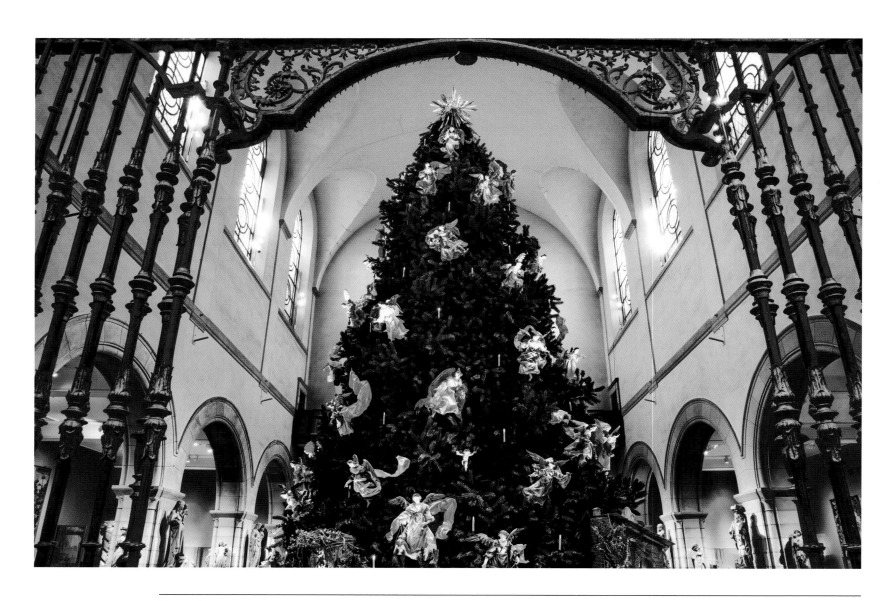

Metropolitan Museum of Art. The Christmas tree and Neapolitan baroque crèche is a longstanding holiday tradition at the museum. A collection of eighteenth-century Neapolitan angels and cherubs hang among the boughs of the twenty-foot candlelit spruce tree. Groups of crèche figures, of which more than 200 have been donated over the years by Loretta Hines Howard, flank the nativity scene at the base of the tree. Recorded music plays in the Medieval Sculpture Hall where the Angel Tree stands.

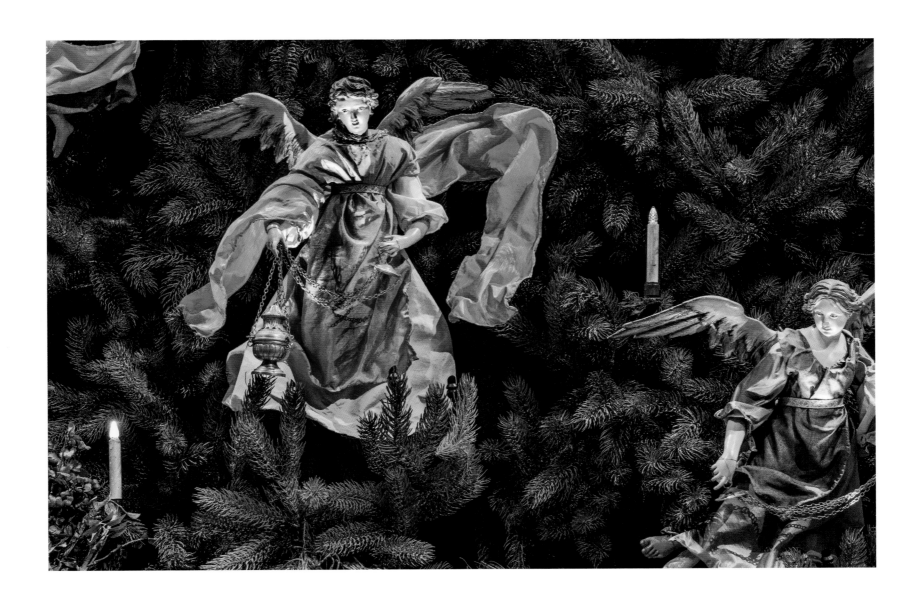

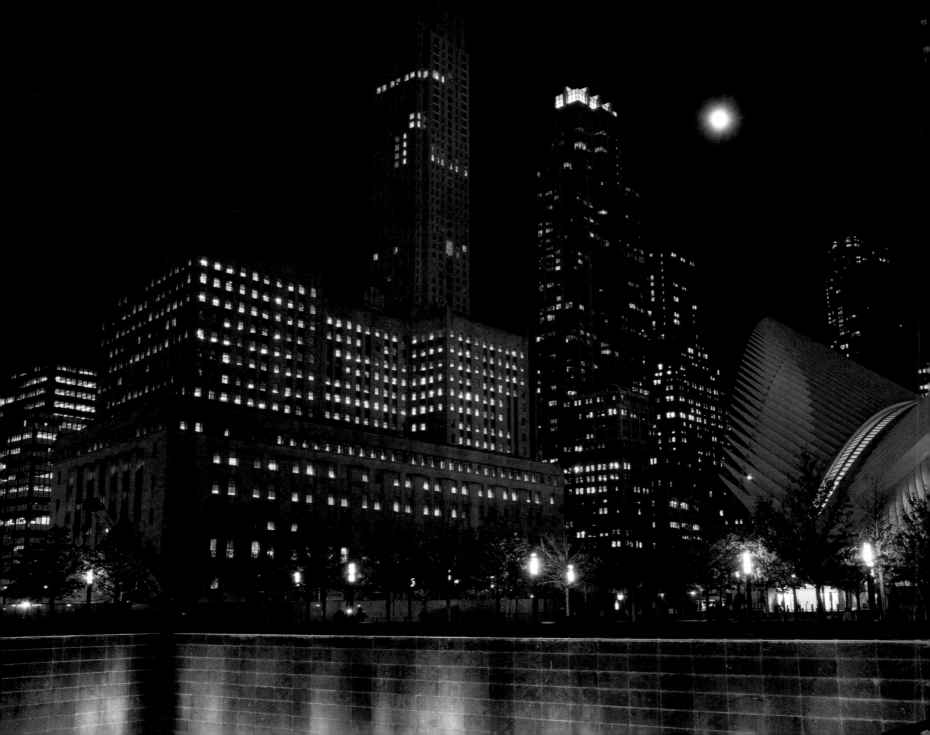

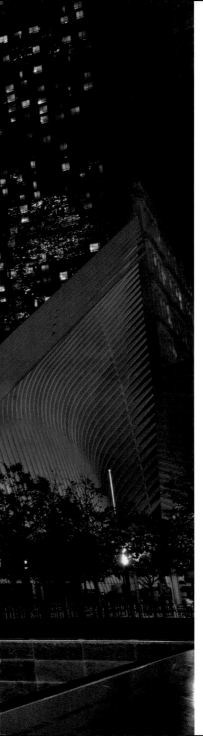

" The days on either side of Christmas are among the busiest of the year at the 9/11 Memorial & Museum, but Christmas Day is quieter. There is a sense of peace, as the water falls unceasingly into the Memorial pools. The trees are bare; yet, they carry the promise of renewal and the imperative of hope, even in this darkest of seasons. The tragedy of 9/11 prompted an extraordinary coming together, a shared recognition of our responsibility to one another. The possibility of hope, the promise of redemption: this is Christmas at the Memorial. **"**

Alice M. Greenwald
President & CEO, 9/11 Memorial & Museum

9/11 Memorial and Oculus. The 9/11 Memorial, in the foreground, commemorates the attacks of September 11, 2001. Behind it is the Oculus, the glass and steel transportation hub designed by architect Santiago Calatrava that resembles a bird in flight. Its purple holiday lights are reflected in the Federal Office Building that houses the Church Street Post Office.

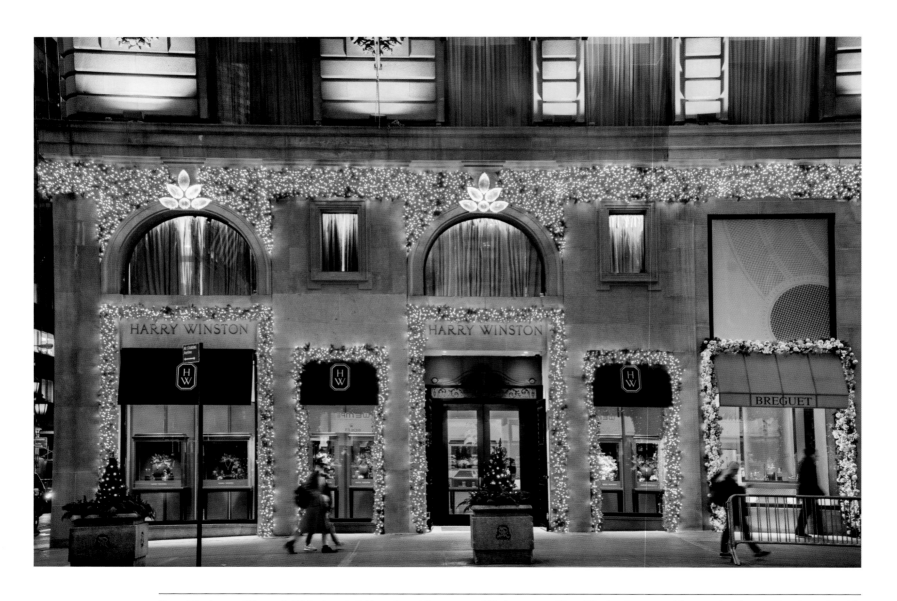

Harry Winston and Breguet. Glistening at night as viewed from across Fifth Avenue are Harry Winston, Inc., one of the premier diamond jewelry and watch retailers, and Breguet, known for its high-complication watches and decorated mechanical timepieces for women.

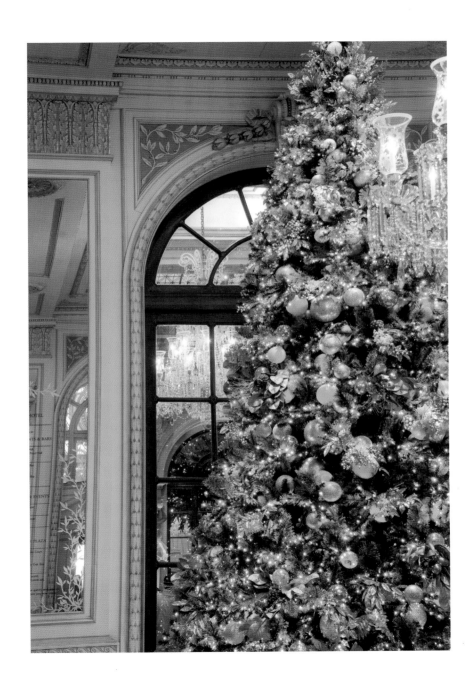

Plaza Hotel. A glistening eighteen-foot Christmas tree graces the lobby of the renowned Plaza Hotel at 59th Street, the setting for lavish social affairs, classic Hollywood films, and a celebrity venue for more than a century.

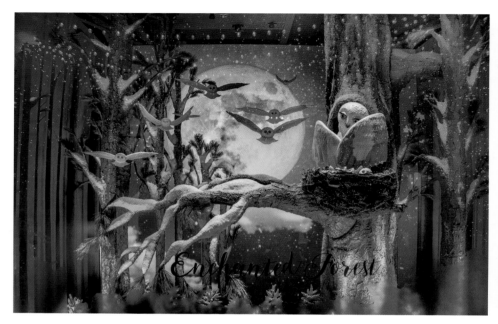

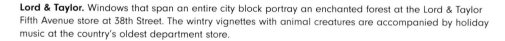

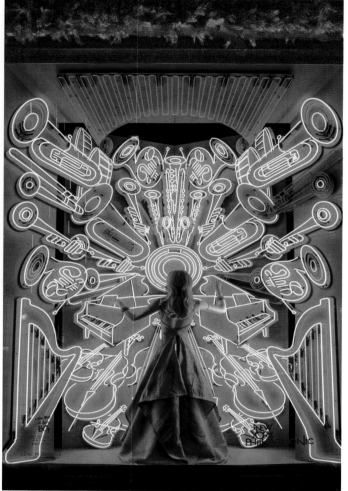

Lord & Taylor. Windows that span an entire city block portray an enchanted forest at the Lord & Taylor Fifth Avenue store at 38th Street. The wintry vignettes with animal creatures are accompanied by holiday music at the country's oldest department store.

Bergdorf Goodman. Praised for the intricacy and opulence of its holiday windows with a different imaginative theme each winter, the Fifth Avenue store pays tribute to the New York Philharmonic in one of seven dynamic windows, each inspired by a different New York cultural institution. A New York landmark since 1901, Bergdorf Goodman showcases leading and emerging designers of luxury goods for women and men.

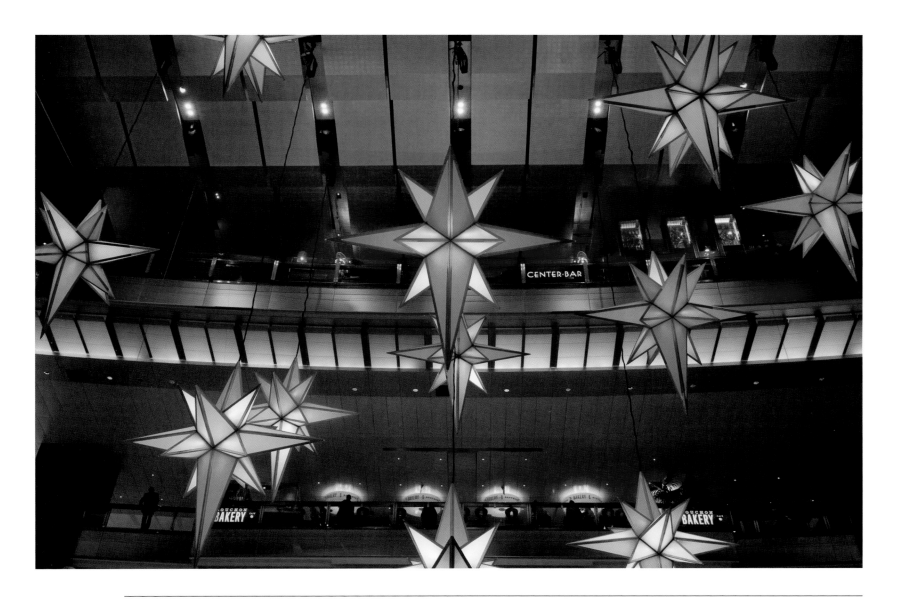

Holiday under the stars. The Shops at Columbus Circle, Time Warner Center, feature a spectacular light show in which twelve fourteen-foot illuminated stars, suspended from the nearly 150-foot atrium, perform choreographed color changes to holiday music. The building, designed by Skidmore, Owings & Merrill, is comprised of upscale shops, Michelin-starred restaurants, jazz destinations, and offices of the media giant Time Warner.

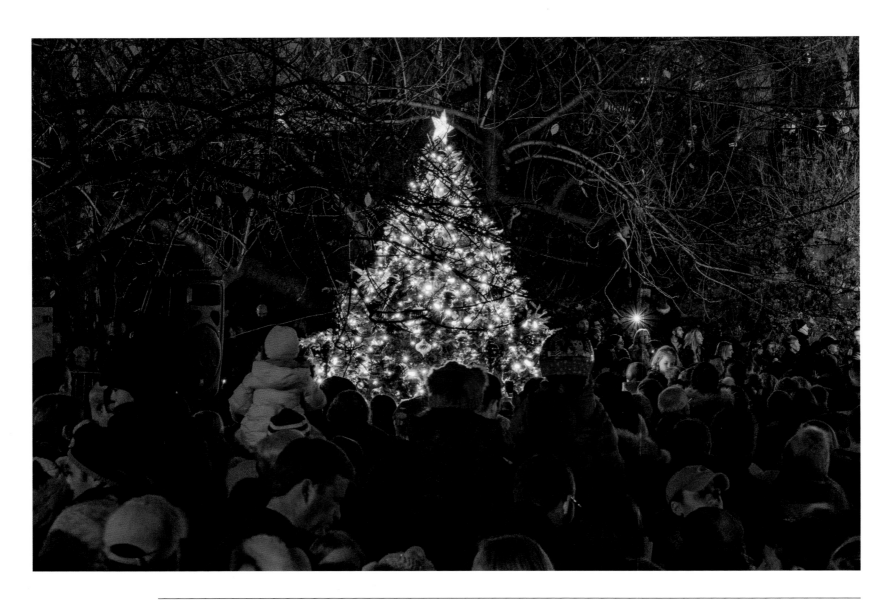

Carl Schurz Park. An annual candlelight and tree-lighting ceremony, organized by its conservancy, is attended by hundreds who live in the Yorkville and Carnegie Hill neighborhoods. Cantori New York, three-time winner of an ASCAP Award, regales the crowd with Christmas carols, followed by a rousing sing-along. Carl Schurz Park, overlooking the East River, has the oldest park conservancy, and one of the most active in the city.

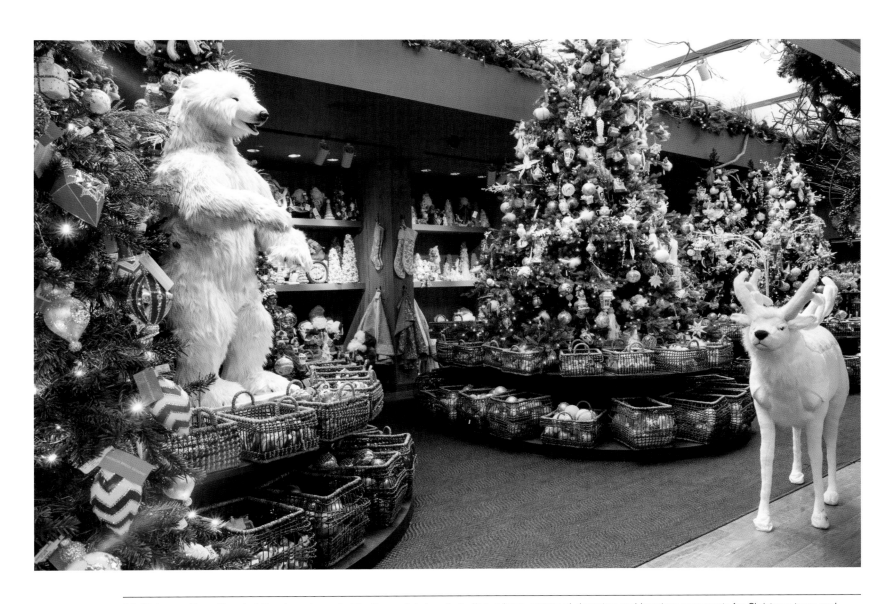

BG Christmas Shop. Bergdorf Goodman is reputed for its special shop that offers a large variety of charming and luxurious ornaments for Christmas trees and tabletops. Many are handcrafted and come from all over the world.

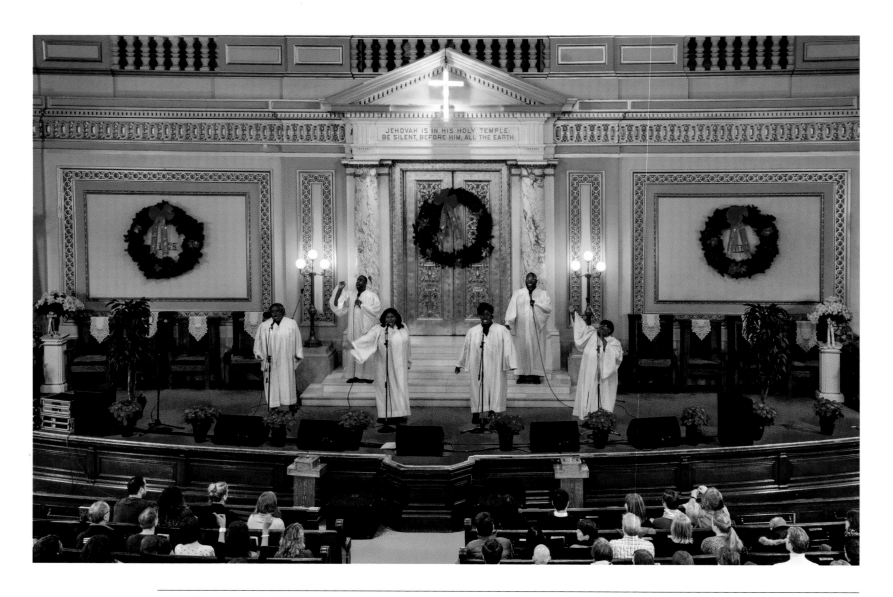

Gospel Jubilee. The Bishop Townsley Jubilee II chorus performs at Mount Olivet Baptist Church in Harlem, formerly a Jewish temple that played a prominent role in African American history in the early twentieth century. This concert, as well as other music and cultural events, is organized by the touring company Welcome to Harlem.

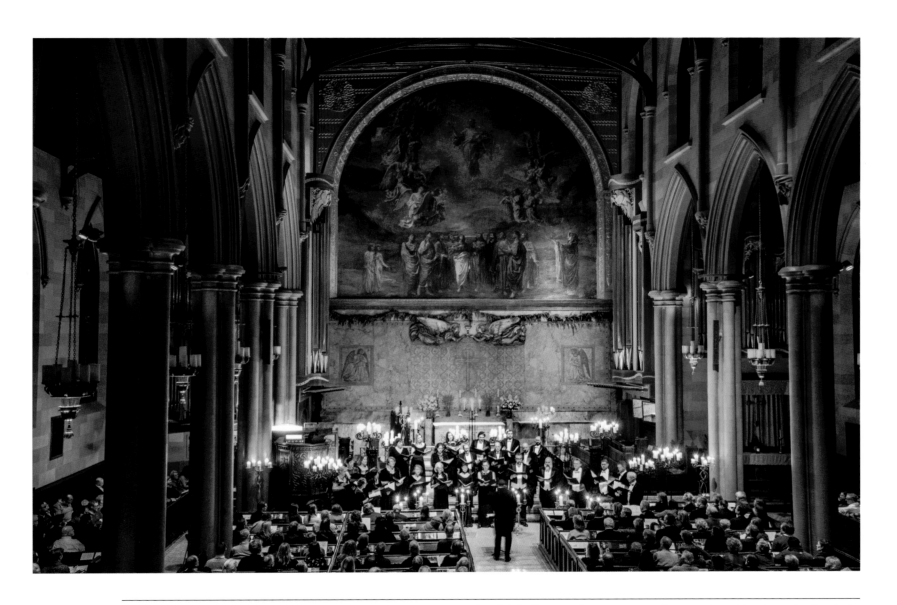

Voices of Ascension. The Grammy-nominated chorus and orchestra offers two Candlelight Christmas Concerts as part of its annual concert series at the Church of the Ascension on Fifth Avenue at 10th Street. The interior of the Gothic Revival-style church was remodeled by Stanford White in the 1880s, with a thirty-five-foot altar mural widely considered the finest mural of esteemed American artist John La Farge.

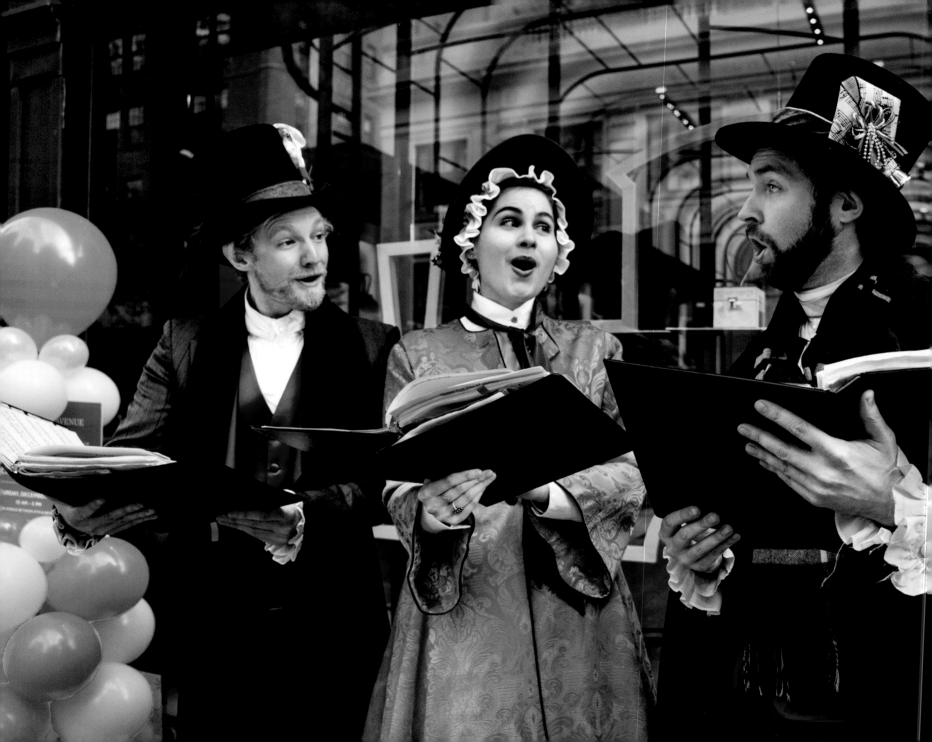

JOY

Victorian carolers. In celebration of the annual Miracle on Madison Avenue, a trio in Victorian costume sings in front of Madison Avenue stores that donate a percentage of the day's sales to benefit the Memorial Sloan Kettering Cancer Center. They are among the professional singers from I S.M.I.L.E. in New York who offer songs of the winter holiday season throughout the city for festive holiday events.

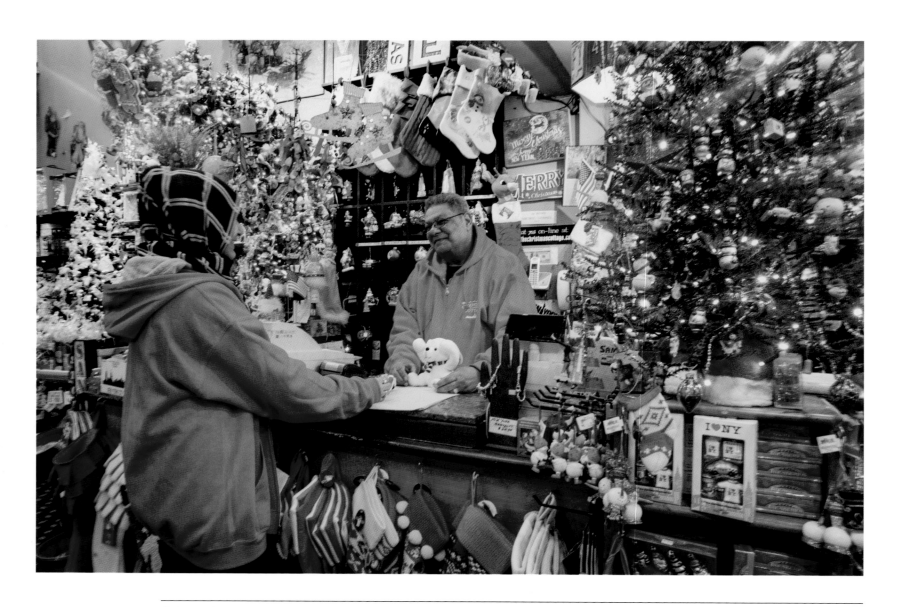

Christmas Cottage. This cozy, family-owned store is stocked to the brim with ornaments, tree decor, stockings, snow globes, and lights. Located on Seventh Avenue at 55th Street, it is New York's oldest Christmas shop and open all year.

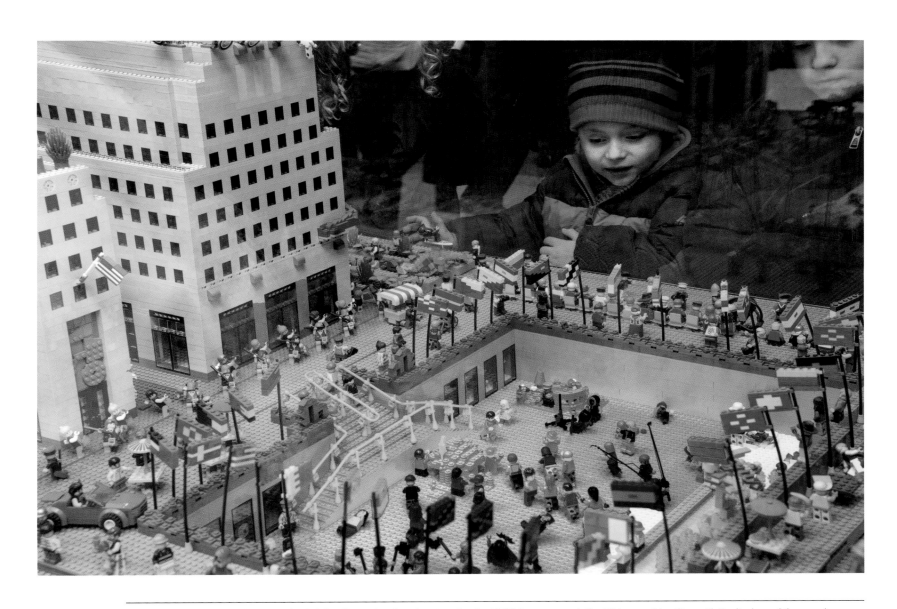

The LEGO Store. The LEGO store at Rockefeller Center is a favorite attraction for LEGO lovers—especially children and families—with its displays of the popular, brightly colored construction toys. A large window features a mini-land model of the skating rink and promenade at Rockefeller Center built exclusively with LEGO bricks and populated with LEGO mini-figures™. Two other LEGO stores in New York are in the Flatiron District and the Queens Center Mall.

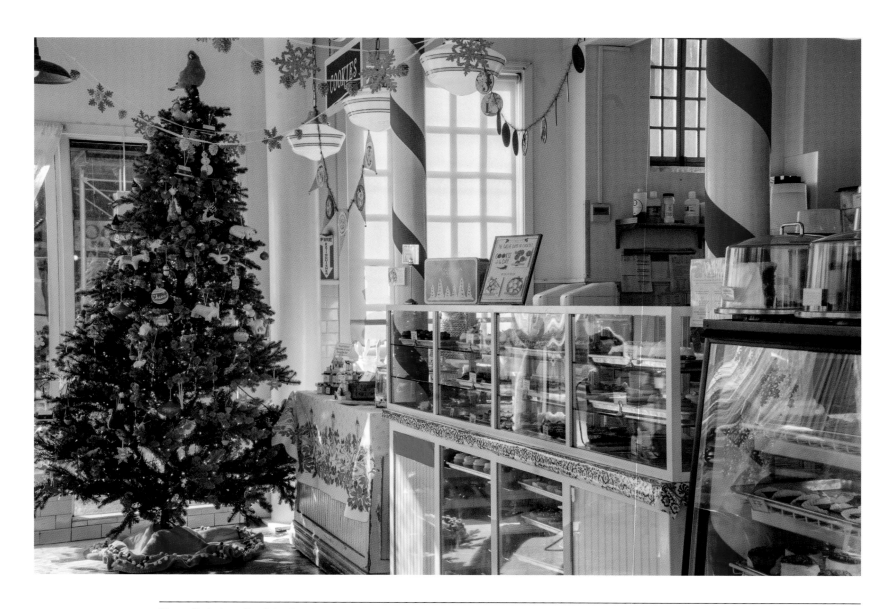

Magnolia Bakery The Columbus Avenue store in the Upper West Side neighborhood is noted for its classic American baked goods, especially cupcakes, muffins, and banana pudding. It offers a congenial place to pause from holiday shopping and relax with a homemade doughnut or cup of hot tea. Magnolia has six bakeshops in New York.

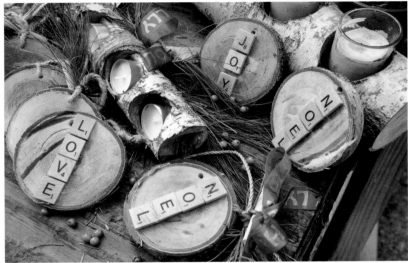

Friedreich's Optik Vintage wooden figurines and evergreen trees adorn the window on Park Avenue at Christmas. The family-run business, founded in 1816, has additional eyewear stores in Palm Beach, Charleston, and Germany.

Holiday candles Candles that are imaginatively set in logs of white birch and adorned with alphabet tiles from a scrabble set are sold by a Christmas tree vendor on the street.

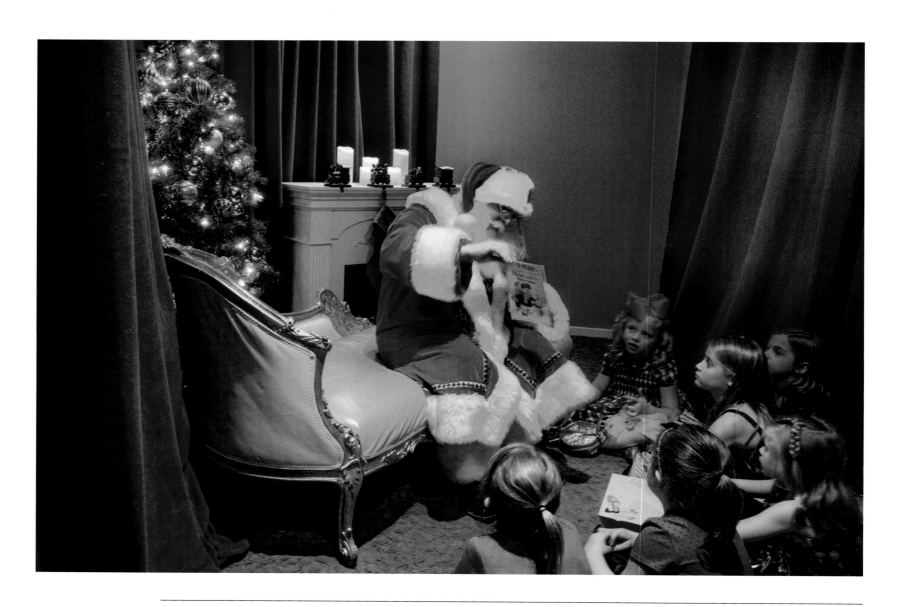

Santa at the Plaza. Santa reads to children at the Plaza in his swanky workshop, one of several opportunities for children to meet Santa at the landmark Plaza Hotel during the winter holidays.

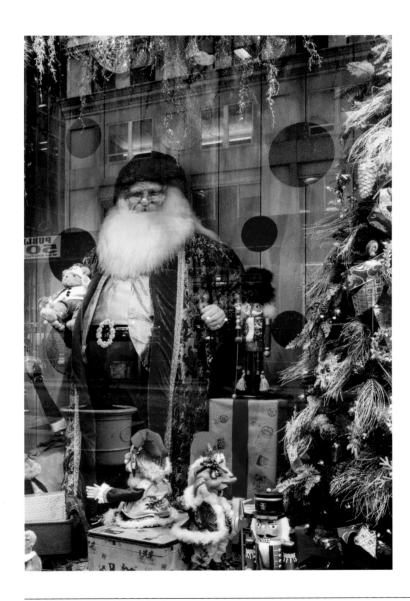

“ No Santa Claus?

It's the memory of 1969 that lingers,
A true white Christmas in New York City.

When it snowed,
And rained music.

Nashville Skyline,
Abbey Road.

Dylan,
Beatles.

And Tommy,
Who . . .

Says there is
No Santa Claus? ”

Clifford Ross
Photographer

Christmas in New York. Santa Claus is the featured subject of a window in one of the shop's seven retail stores in New York.

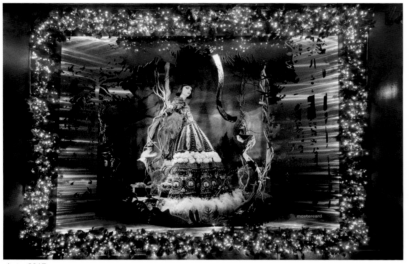

photo: 2017

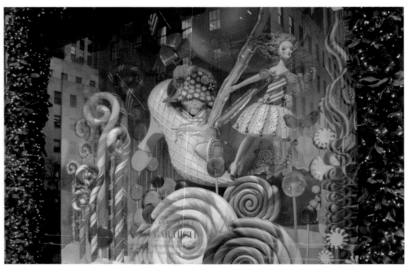

photo: 2016

Saks Fifth Avenue. For more than ninety years, the holiday windows at the flagship New York store have attracted thousands of shoppers and onlookers. One window (right) shows a magical landscape of colorful candy based on the 2016 window theme, Land of 1,000 Delights. Another (left), with the 2017 theme Once Upon a Holiday, shows a fairytale gown for a twenty-first-century Snow White by fashion designer Naeem Kahn. Both are framed by the glittering garland that outlines all of Saks Fifth Avenue's windows.

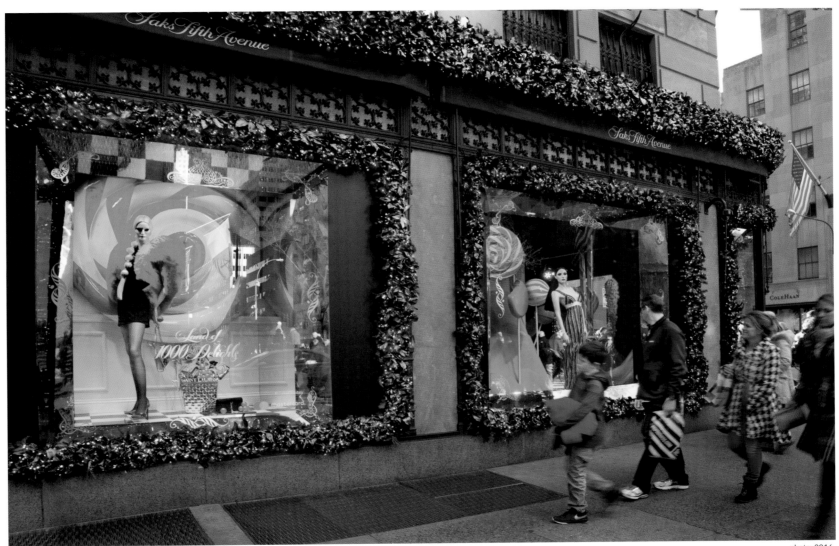

photo: 2016

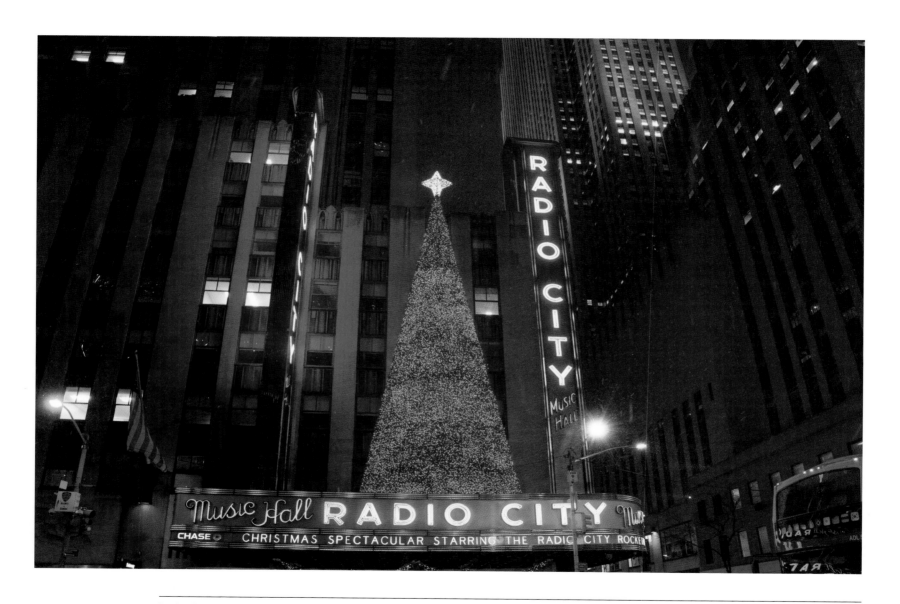

Radio City Music Hall. The grand entertainment venue is best known for its Christmas Spectacular starring the Radio City Rockettes®, New York's legendary high-kicking dance troupe. The event has filled 6,000 seats several times a day throughout the holiday season since 1933. The seventy-two-foot Christmas tree on the façade was designed and installed by American Christmas, Inc.

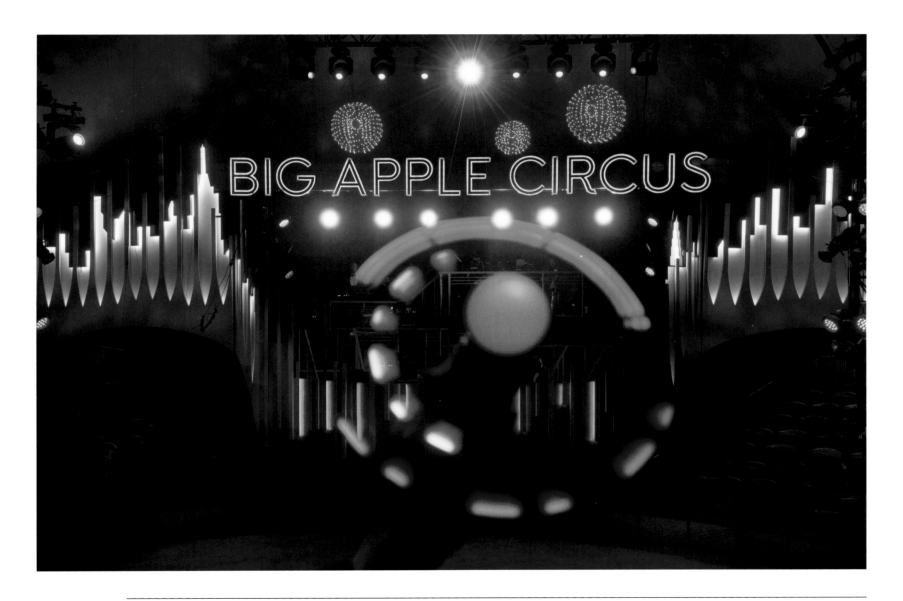

Big Apple Circus. The forty-year-old circus is one of New York's most popular tourist attractions for families at holiday time. Located in a tent in Damrosch Park at Lincoln Center for the Performing Arts, the extravaganza features the Big Apple's hallmark trapeze act, high-wire feats, and galloping horses in formation. The circus travels nationwide the remainder of the year and has become known for its community outreach programs.

I think of Harlem during the Christmas holidays and the spirit of love, family, and community there. I think of the Kwanzaa celebration and holiday shows at the Apollo Theater. I look forward to the tree lighting at the Harlem State Office Building and to purchasing holiday gifts from the street vendors. I marvel at the light display that crosses above 125th Street that's mounted by the Business Improvement District. Finally I love when everyone you pass says 'Happy holidays' no matter who you are or where you're from. Let there be peace on earth. "

Billy Mitchell
Apollo Theatre Ambassador and Director of Tours

Apollo Theatre. Staff decorate the marquee of the famous theater for its annual Winter Wonderland event sponsored by Coca-Cola.

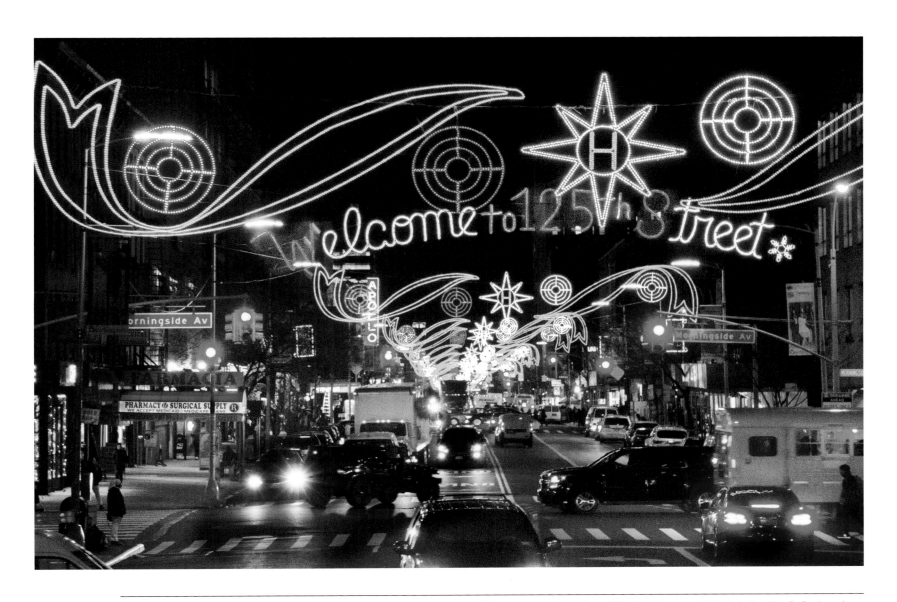

Harlem. The African American residential, cultural, and business center is festive at Christmastime, particularly on 125th Street, co-named Martin Luther King Jr. Boulevard. Notable buildings along the street include the Apollo Theatre, the Studio Museum of Harlem, the Harlem Children's Zone, and the Mount Morris Bank Building.

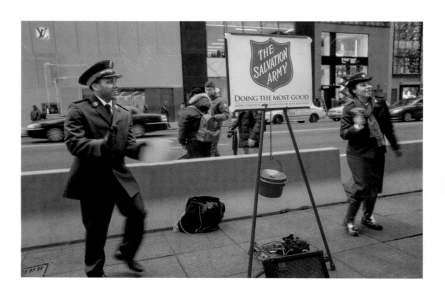

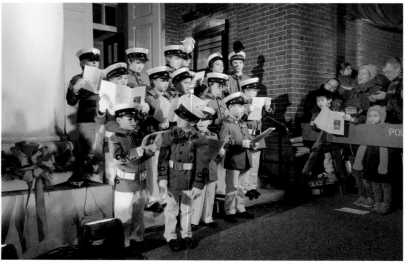

Salvation Army. Volunteers of the international Christian charitable organization stand on many streets playing Christmas carols or ringing bells to inspire passersby to place donations inside red kettles. Their Red Kettle Campaign, which started in San Francisco in 1891, enables the Salvation Army to provide food, toys, and clothing to more than six million people during the Christmas season.

Knickerbocker Greys. Cadets from this nonprofit organization sing at the Brick Presbyterian Church ceremony for the lighting of the Park Avenue trees. The organization provides after-school training in leadership, confidence, and character development.

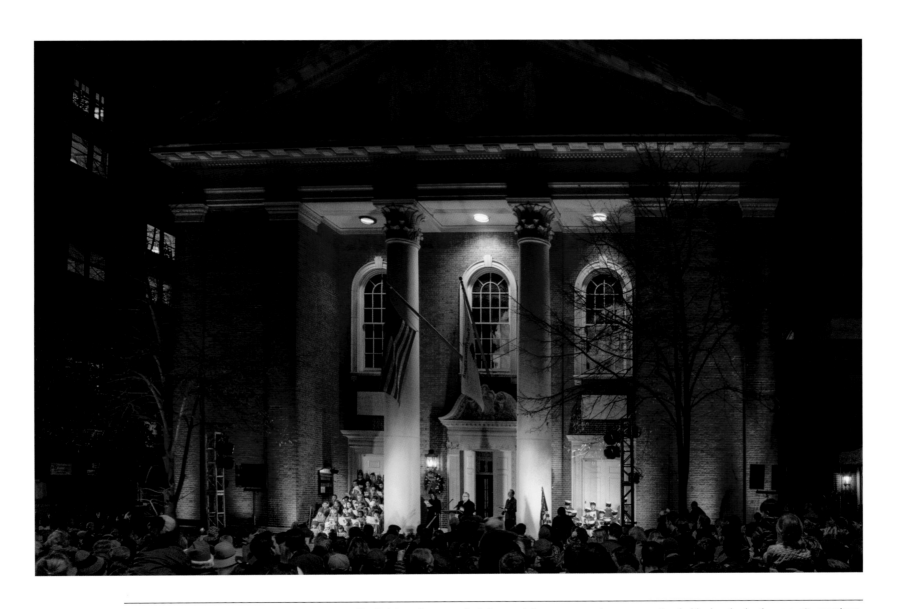

Brick Presbyterian Church tree lighting ceremony. The lighting of trees on Park Avenue follows an annual ceremony attended by hundreds of community members who gather and sing Christmas carols outside the church at 91st Street.

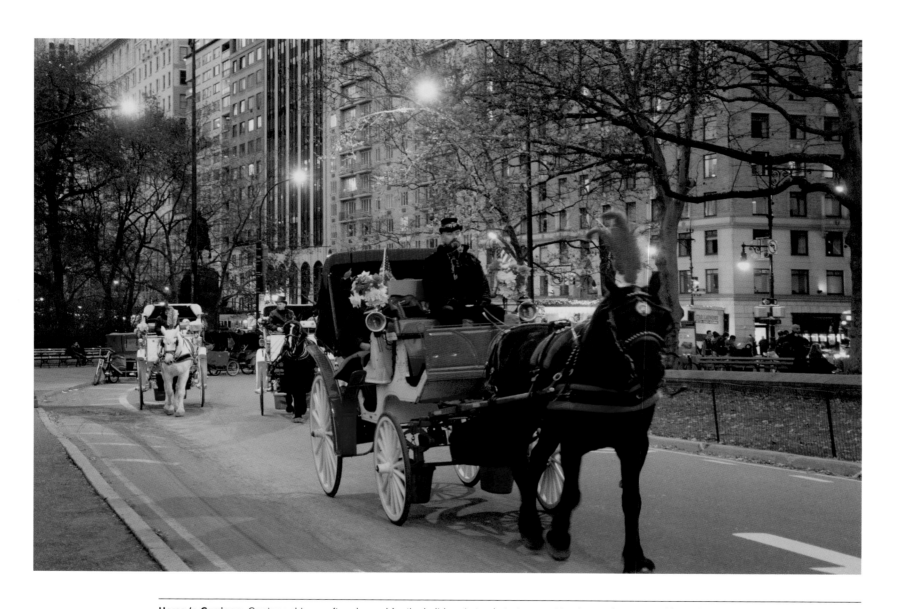

Horse 'n Carriage. Carriage drivers, often dressed for the holidays in top hats, transport tourists on the streets of New York. They provide blankets for warmth during the colder months.

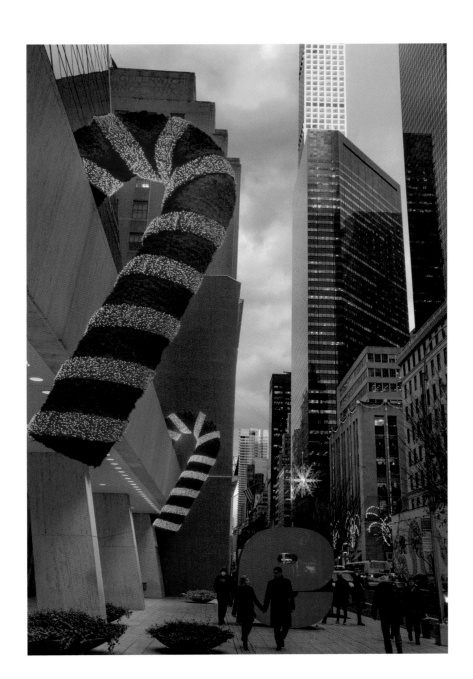

9 West 57th Street. The Solow Building Company adorns its 57th Street property, distinctive for its sloping façade, with giant, eighteen-foot-tall candy canes. The broad sidewalk is lined with trees that glisten with tiny lights in front of the fifty-story office building, designed by Gordon Bunshaft of Skidmore, Owings & Merrill.

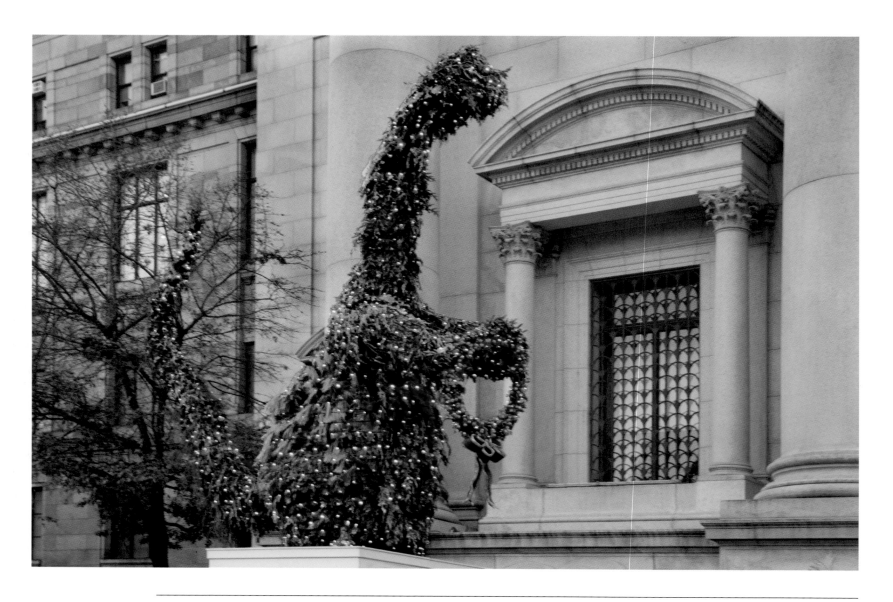

American Museum of Natural History and The New York Public Library. One of the two marble Library Lions®, each adorned with holly wreaths on either side of the majestic New York Public Library building, greets readers and passersby on Fifth Avenue. Dinosaur-shaped topiary trees welcome visitors to the American Museum of National History on Central Park West.

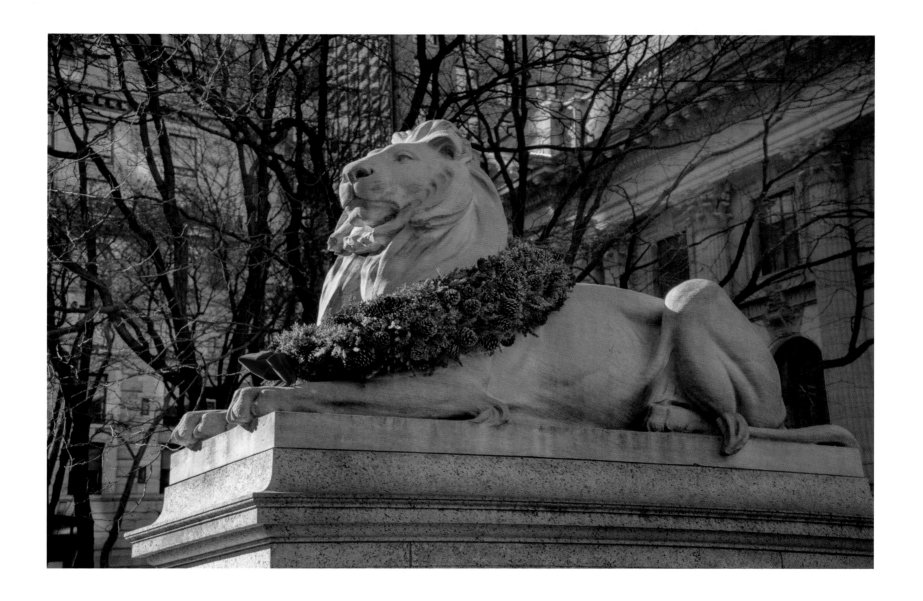

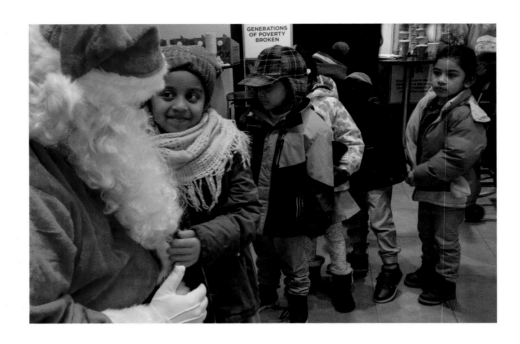

"Born in New York City to Taiwanese immigrant parents, and educated in the public-school system, I was exposed to both the wonders of urban living and its diverse cultures, as well as its stark inequalities, especially across neighborhoods. The holiday season is a time when New Yorkers from all walks of life should embrace each other with care and generosity and show special concern for those most vulnerable in this city we all call home.**"**

Anthony Shih, MD
President, United Hospital Fund

The New York Foundling. Children from the South Bronx, most of whom are in the child welfare system or in preventive programs, come to the Foundling headquarters near Union Square Park, where they are embraced by Santa Claus. Each child selects one of hundreds of wrapped gifts donated by the MTA Bridge and Tunnel Association. The New York Foundling is one of the largest providers of social services to vulnerable children and families in New York, and distributes more than 6,000 gifts at holiday time throughout the five boroughs.

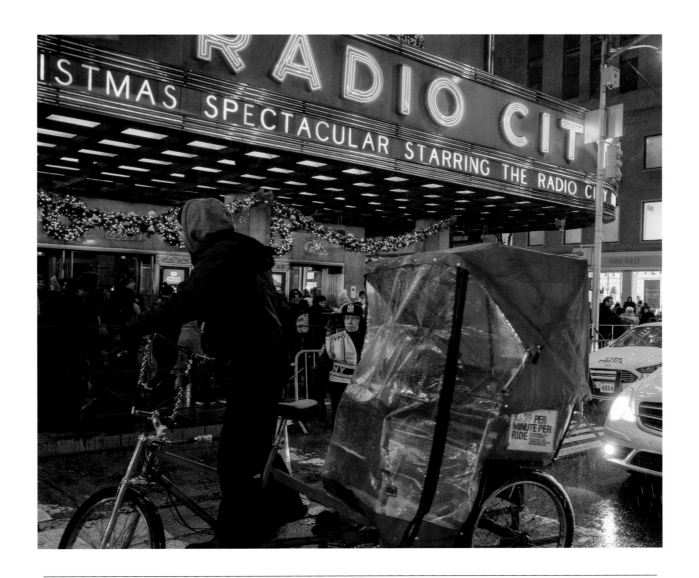

Pedicabs rides. Brightly colored pedicabs for hire, with canopies and waterproof coverings for inclement weather, can be seen all over the city. They take pedestrians on short trips, tours of Central Park, and other sight-seeing excursions.

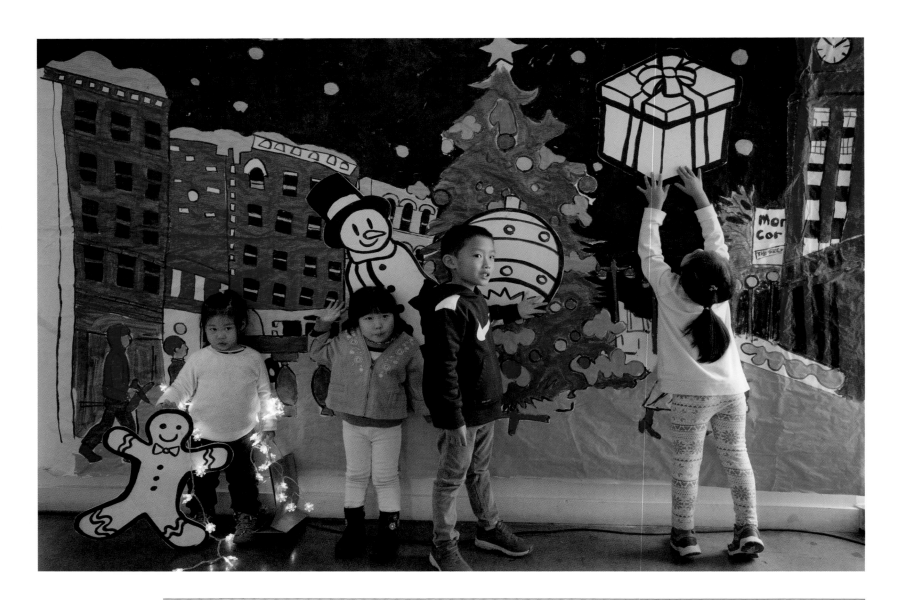

Bronx Museum of the Arts. Children show their black-and-white cut-outs against a painted holiday mural at the Winter Wonderland celebration. The entire museum is open for art and music activities at this annual family event. The museum makes art accessible to the Bronx community's diverse population through exhibitions, public programs, connections to local schools, and a free admissions policy.

Dylan's Candy Bar. The imaginative and vibrant colors of candy, candy gifts, and candy-inspired products are reflected in the playful holiday windows of the flagship store on Third Avenue at 62nd Street. The three-floor venue also features a Candy Café and a party room for candy-themed events. The brand, created by Dylan Lauren in 2001, has since expanded to cities throughout the US and abroad.

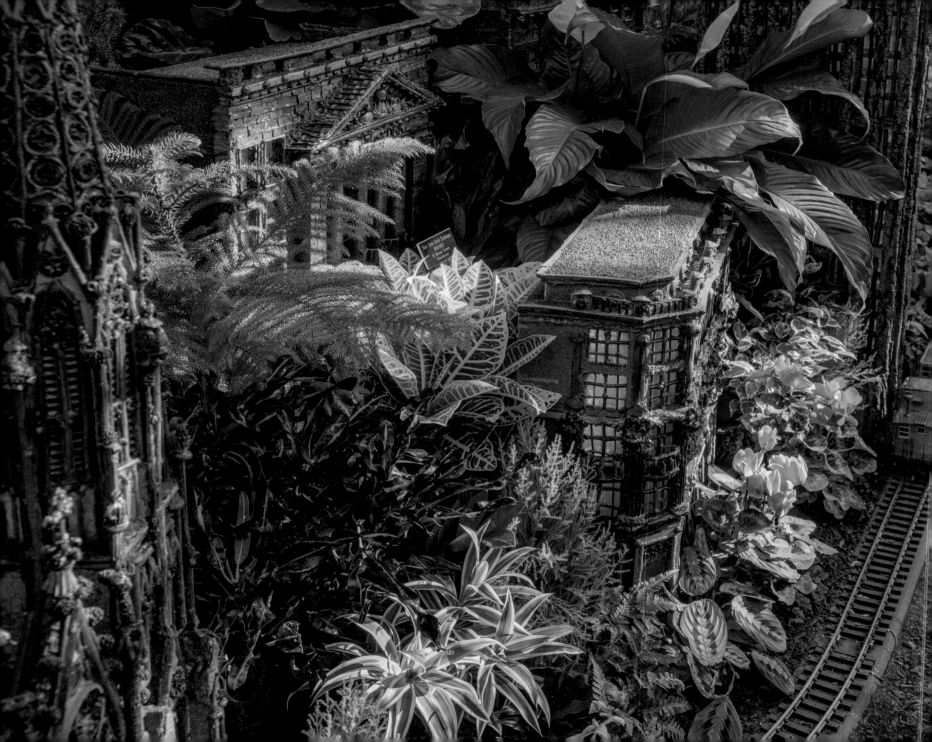

66 When the December days grow short and my office window is black by 4:15, I find myself longing, already, for spring. That is, until I hit the sidewalks of Manhattan and the brilliant store windows of Christmas, illuminating the streets, banish all thoughts of daffodils. It's dark now, but not in the streets of New York—and not in the grand Holiday Train Show at the Botanical Garden. The whole city has become a festival of lights. **99**

Gregory Long
President and CEO, The New York Botanical Garden

The New York Botanical Garden. Electric model trains zoom past 150-plus replicas of famous New York landmarks at the Holiday Train Show that has been presented for more than twenty-five years at the Garden in the Bronx. The replicas are created with bark, leaves, and other natural materials. Pictured above are St. Patrick's Cathedral, the New York Stock Exchange building, and Saks Fifth Avenue, by artist Paul Busse from Applied Imagination. The Holiday Train Show® takes place in the Enid A. Haupt Conservatory, a Victorian-style glass house.

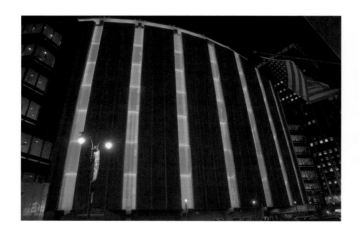

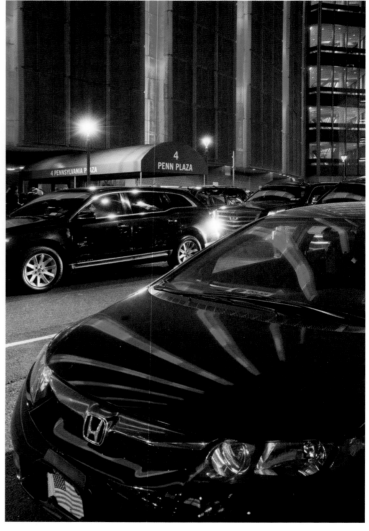

Madison Square Garden. At Christmastime the vast indoor arena on top of Pennsylvania Railroad Station is distinguished by its red and green striped lights that are reflected in nearby cars. Madison Square Garden is a major sports event facility and an important music venue for concerts with very large audiences.

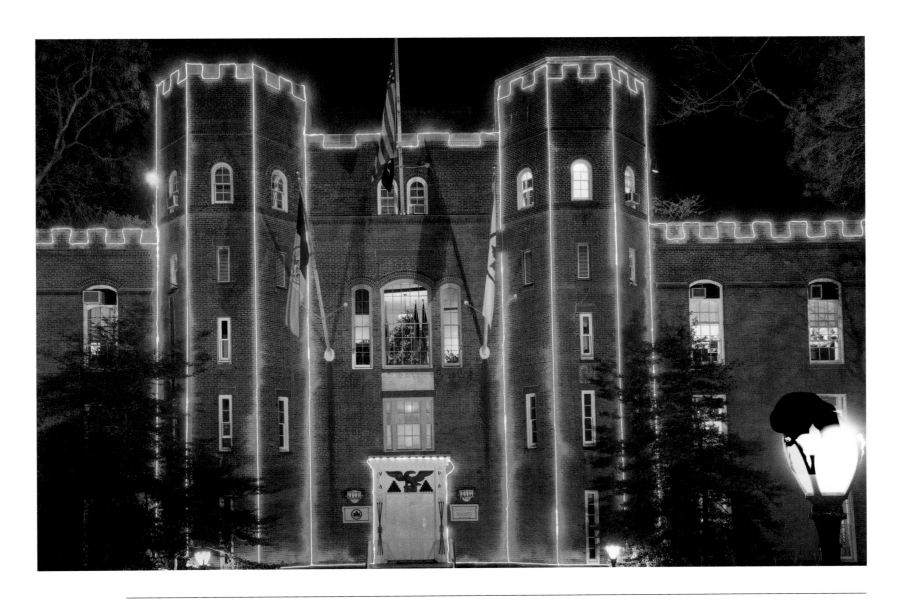

Central Park Arsenal. The mid-nineteenth-century, fortress-like brick building on Fifth Avenue in Central Park is outlined with green lights at Christmastime. Built to store arms and ammunition, it now houses the offices of the New York City Department of Parks and Recreation and the Central Park Wildlife Conservation Center.

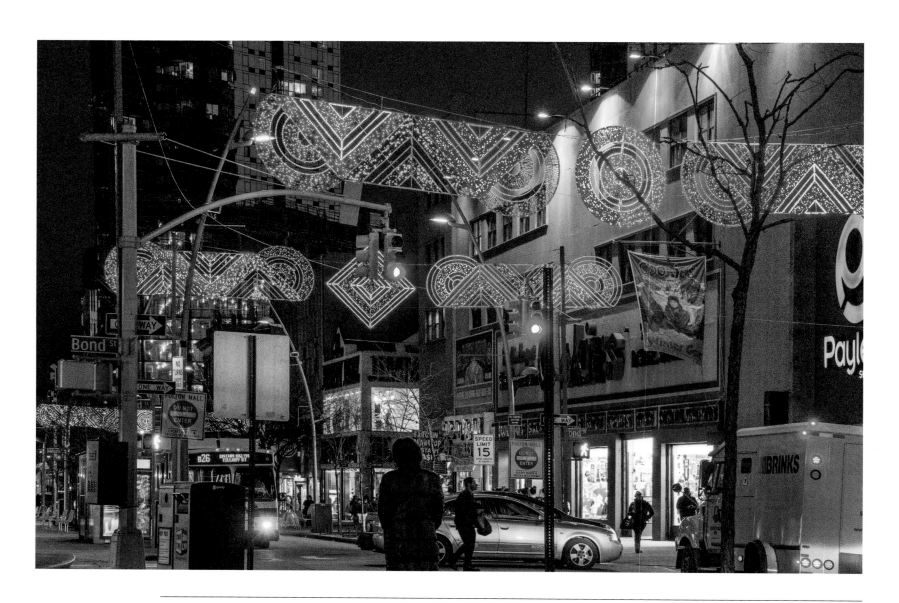

Downtown Brooklyn. Fulton Street, lined with dozens of stores, is decorated with vibrant, over-the-street lights at holiday time.

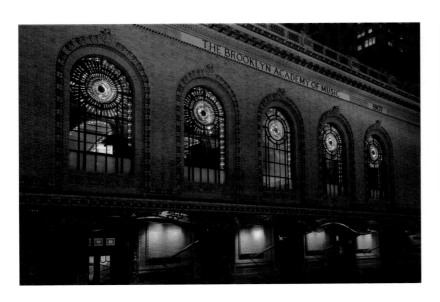

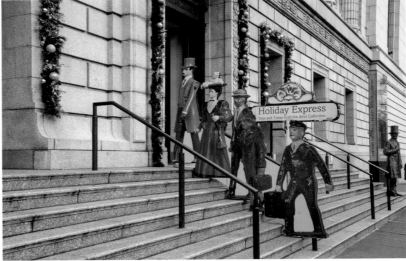

Brooklyn Academy of Music (BAM). Five double-height windows extend across the second-floor façade of the Peter J. Sharp building designed in the Beaux-Arts style at the turn of the twentieth century. This leading performing arts center has developed a reputation for cutting-edge theater, music, film, dance, and opera.

New York Historical Society. The city's first museum, established in 1804, houses distinguished collections, a library, and exhibitions that focus on the history of New York and the nation. Life-size cardboard cutouts that replicated miniature toy figurines of the 1890s-1930s, adorned the museum's steps and welcomed visitors at Christmastime 2017.

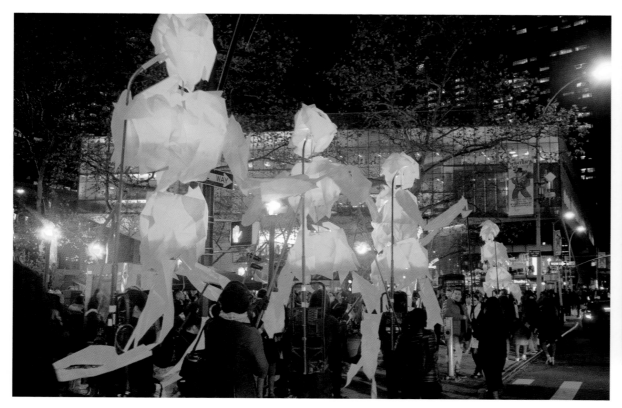
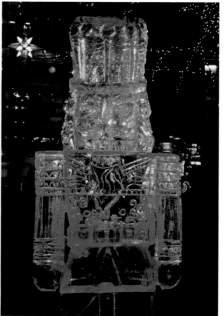

Winter's Eve Festival. The one-night festival begins with a tree lighting ceremony in Dante Park across from Lincoln Center for the Performing Arts. Musicians, food vendors, dancers, people on stilts, and other street performers participate. There is a procession of illuminated, thirteen-foot-tall puppets called the Frost Giants, created by the Processional Arts Workshop. A nine-foot-high ice sculpture is carved by master ice sculptor Shintaro Okamoto of the Okamoto Studio in Queens, which creates imaginative ice sculptures for special events. The Lincoln Square B.I.D. hosts the festival, and the presenting sponsor is Time Warner, Inc.

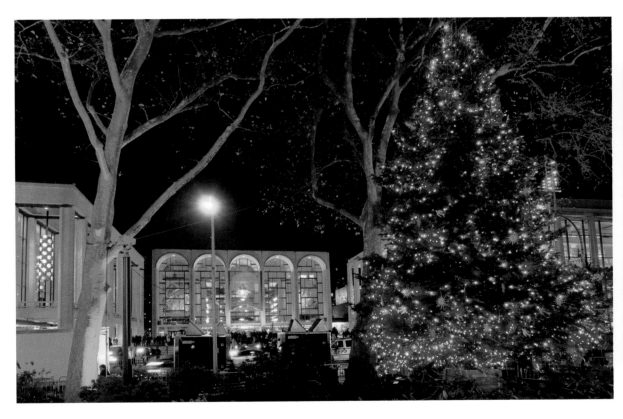

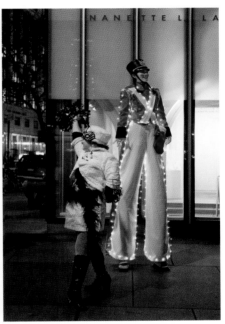

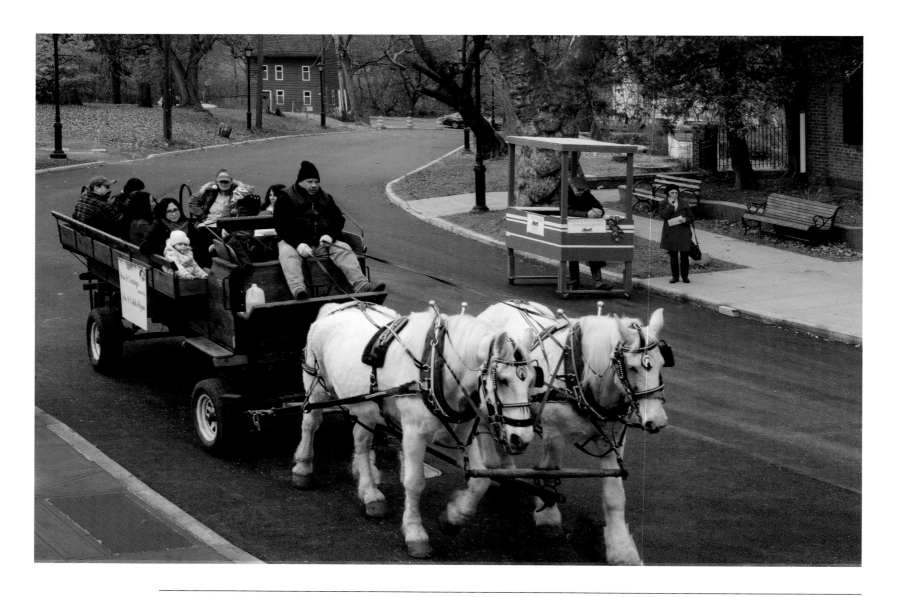

Richmond Town. The Christmas holidays are an optimum time to visit the restored buildings and shops in Richmond Town on Staten Island, where traditional holiday celebrations and decorations abound. Women in period costume baking gingerbread is one of several demonstrations that can be viewed while touring the authentic town by foot or in a horse-drawn wagon. Holiday festivities include games, contests, a tree lighting ceremony, carolers, a bell choir, and tavern-style dining.

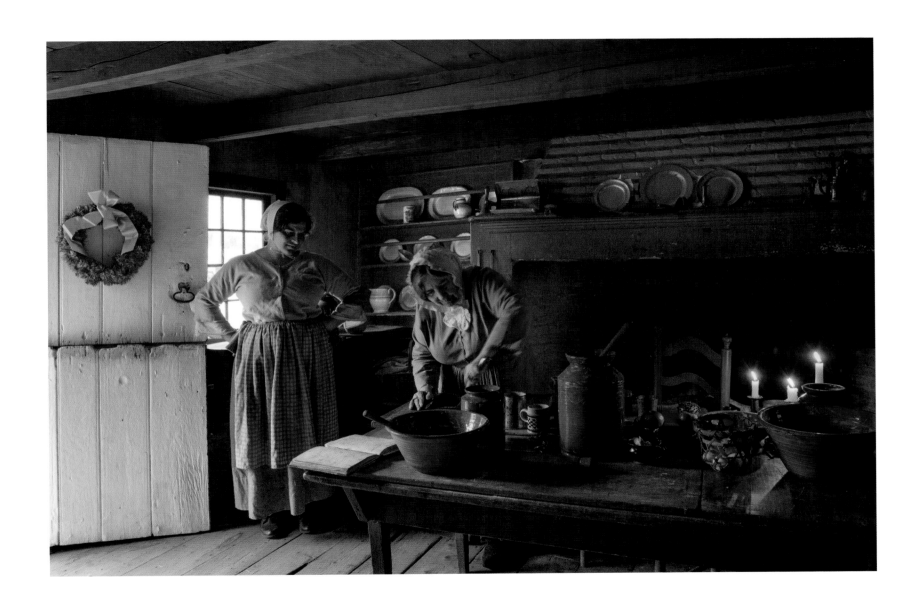

Bryant Park and Union Square holiday markets. Oases of greenery in summer months, both Bryant Park (above) and Union Square Park (opposite) are transformed into holiday shopping destinations, each with more than 150 kiosks offering unique gifts by local craftsmen and artists. Bryant Park, the two-square-block park behind the landmark New York Public Library building, also has a 17,000-square-foot skating rink that offers free skating in the heart of midtown Manhattan.

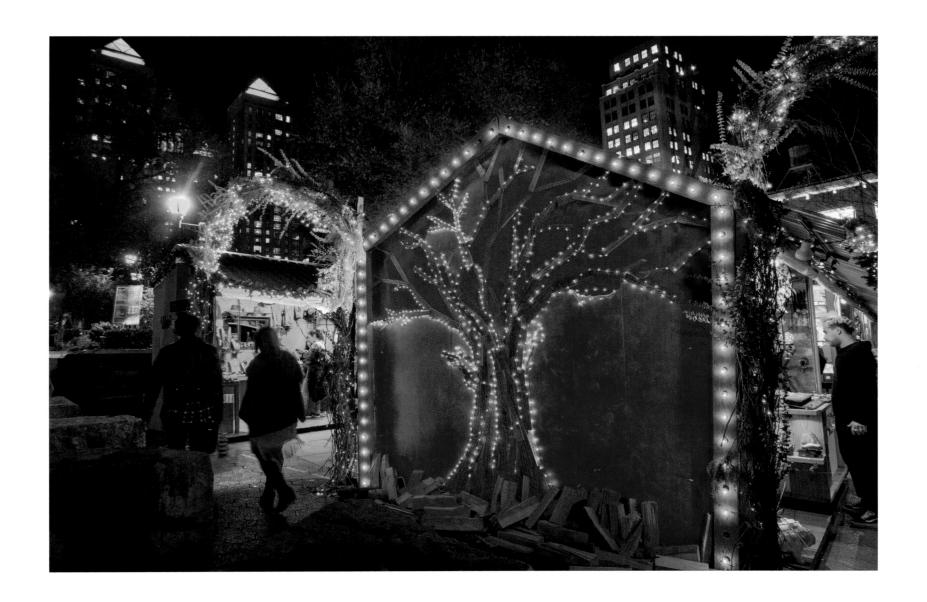

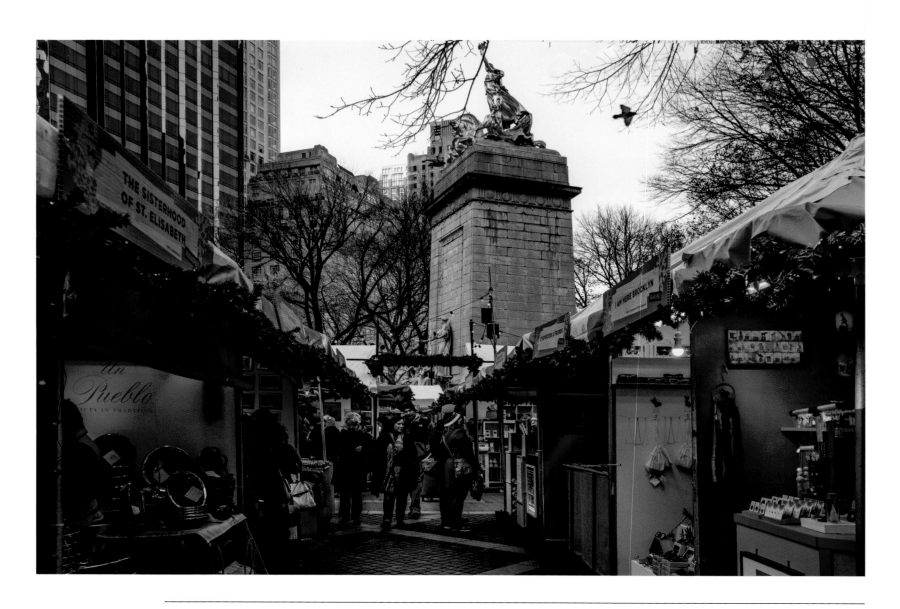

Columbus Circle Holiday Market. The annual outdoor bazaar features dozens of booths that sell jewelry, home accessories, food, and crafts by local and international artisans. Located at the corner of Central Park West at 59th Street, it is open day and evening for holiday shopping. One vendor sells intricate, colorful mosaic lamps, lanterns, and ceramics from Turkey, while another sells Swedish paper star lanterns.

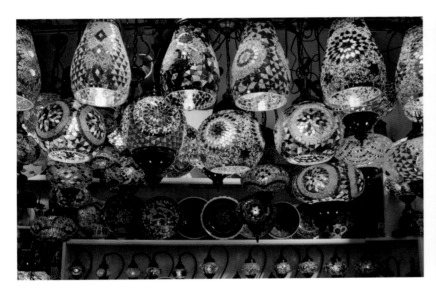

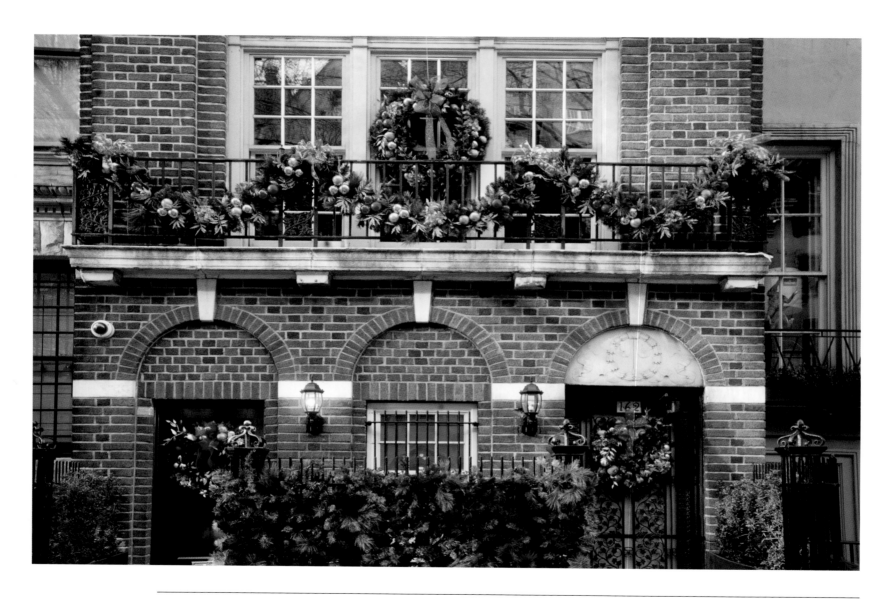

Townhouses throughout the city are decorated with garlands and wreaths.

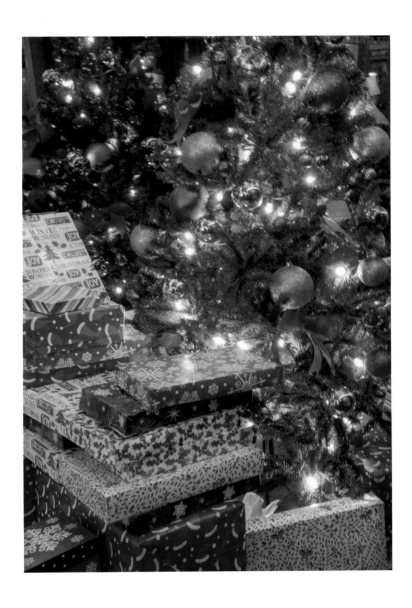

66 **Thirty-two years at the job, and Christmas is definitely the best time of the year. My mailbags get heavier with all the sale catalogs, but I get to see boxes with designs, and gifts with extravagant wrapping, not just the usual manila or white envelopes. And, of course, I appreciate the tips that come my way.** 99

Jesse Porter
Postman

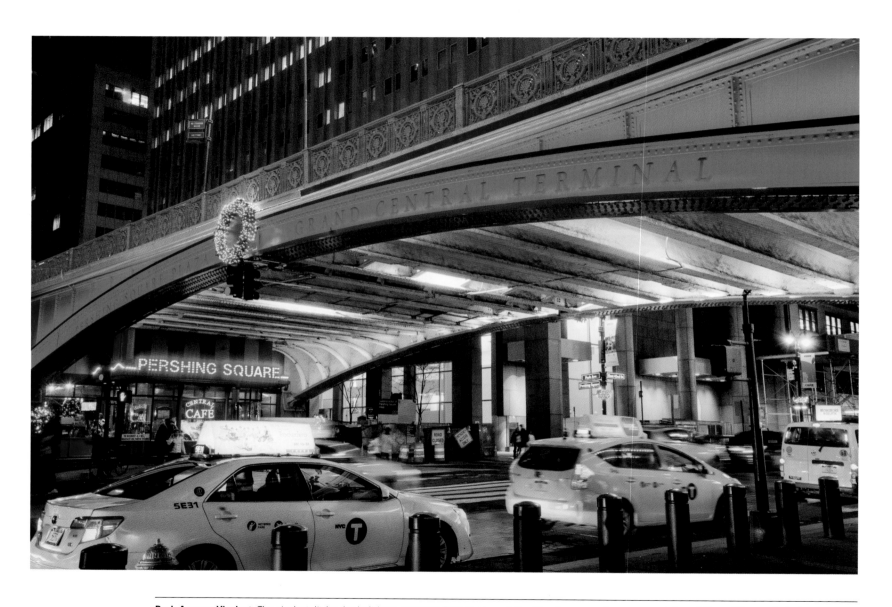

Park Avenue Viaduct. The viaduct, lit for the holidays, connects Park Avenue at Pershing Square and goes around Grand Central Terminal, the busiest train station in America.

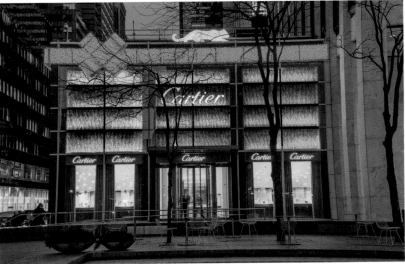

Cartier. The luxury French jewelry company, founded in 1847, and headquartered in Paris, has two locations on Fifth Avenue in New York – Cartier Central Park at 59th Street (right), and the legendary mansion at 52nd Street (left), Cartier's flagship store, which is wrapped with a giant red bow.

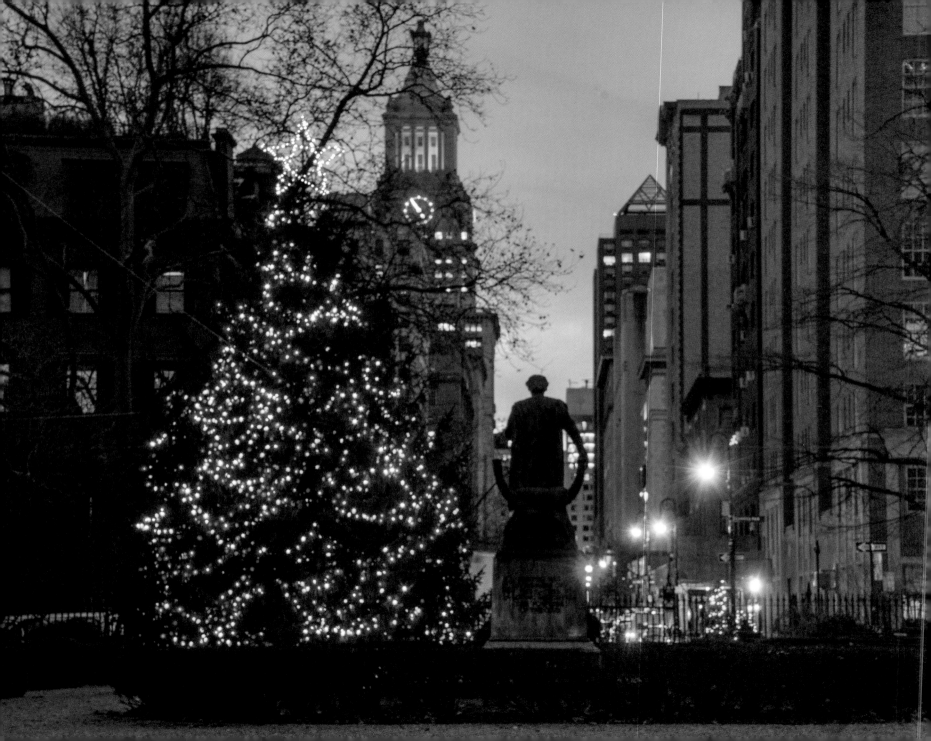

ROMANCE

Gramercy Park. The two-acre private park from East 20th to 21st Street is surrounded by a wrought-iron fence to which only owners of the stately homes facing the park have keys. However, its forty-foot Christmas tree can be enjoyed by all who walk by, and the park has a tradition of opening its gates to the public for caroling on Christmas Eve, sponsored by the Trustees of Gramercy Park. When the tree is taken down in early January, its trunk and branches are used for mulch in the tree beds surrounding the park.

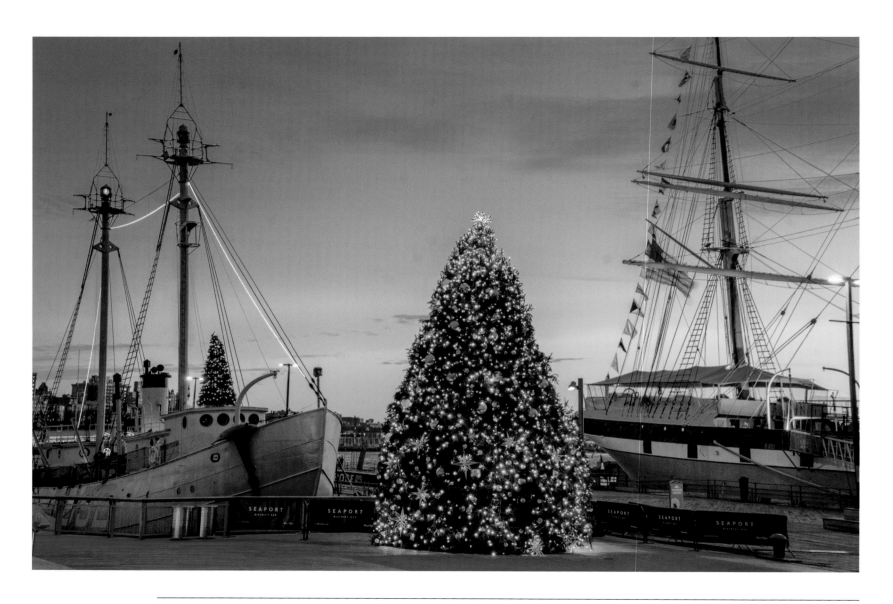

South Street Seaport. The lightship *Ambrose*, built in 1907, and the 1885 cargo ship *Wavertree* are two of the historic vessels docked at the historic waterfront. A sixty-foot Norway spruce also sparkles on the wharf as the sun goes down.

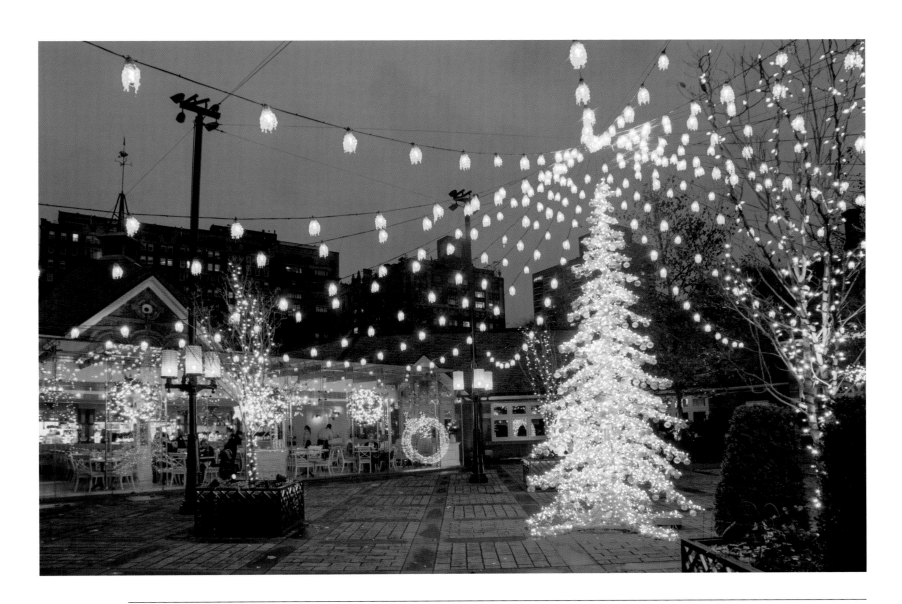

Tavern on the Green. This landmark restaurant in Central Park offers a unique winter dining experience with views of the dramatic holiday illuminations in the adjacent garden. It was built in 1870, to house the sheep that grazed in Central Park until New York City Parks Commissioner Robert Moses transformed it into a restaurant in 1934.

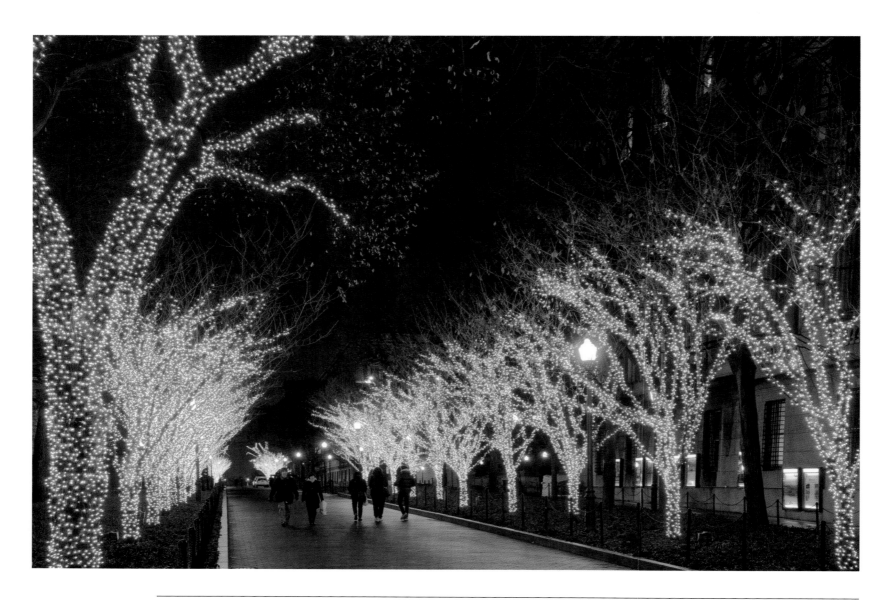

Columbia University. Trees are illuminated along College Walk, the university's main public passageway between Broadway and Amsterdam Avenues at West 116th Street. Columbia is one of the leading private institutions of higher education in America, established in 1754.

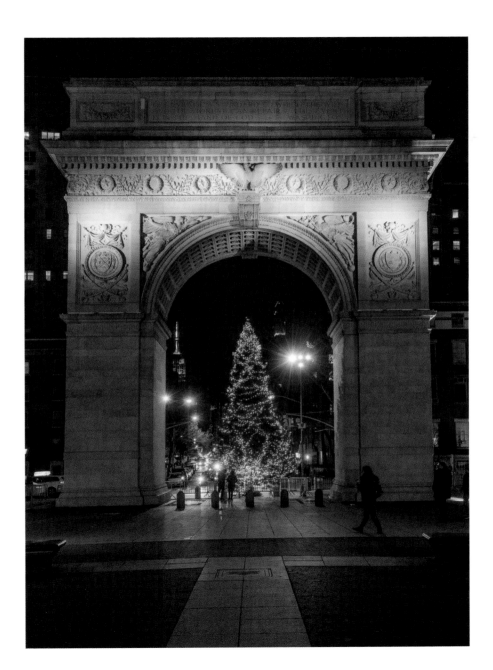

Washington Square Arch. The Christmas tree under the marble arch, provided by the Washington Square Association, is a decades-old tradition. Holiday songs are sung at the annual tree lighting and carols are sung there on Christmas Eve. The arch, designed by New York architect Stanford White and modeled after the Arc de Triomphe, dominates the nearly ten-acre public park in Greenwich Village.

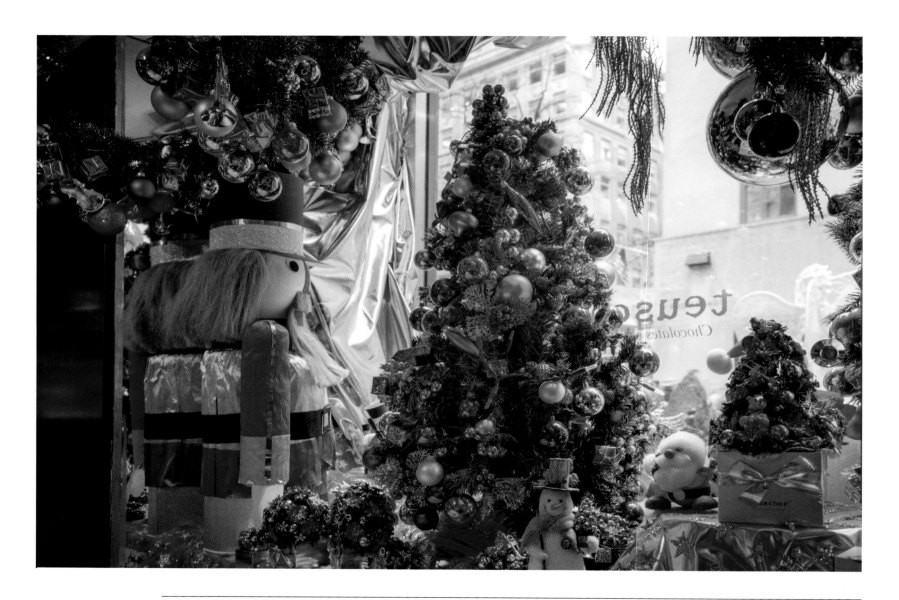

Teuscher. Headquartered in Zurich, the brand is famous for its chocolates and truffles that are flown weekly to shops in cities on four continents, including its store in the promenade of Rockefeller Center. Founded more than eighty-five years ago, Teuscher is also well known for the elaborate decoration of its its shops and its gift box presentation.

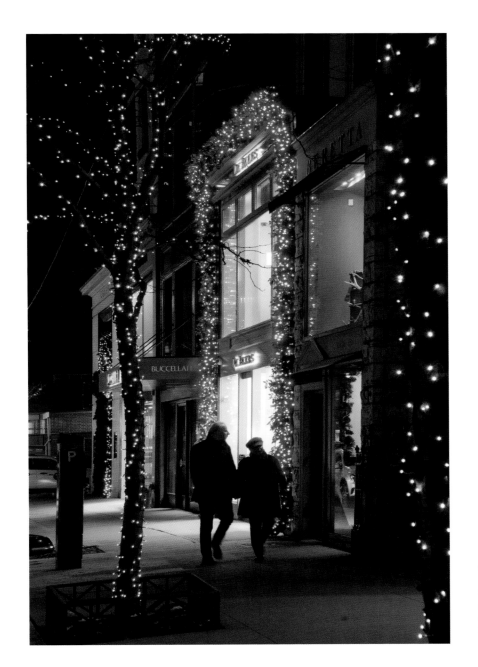

De Beers Diamond Jewelers. The blue holiday lights that frame the window of the boutique on Madison Avenue at 63rd Street echo the blue and white colors of the store. Here, De Beers showcases the full range of its natural, untreated diamonds and fine diamond-crafted jewelry.

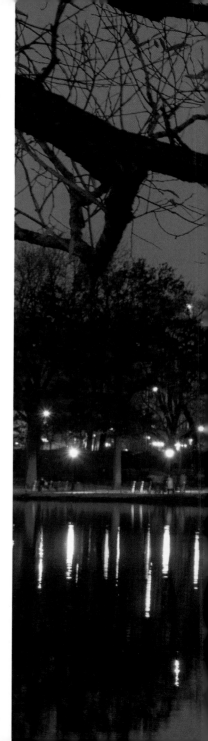

"While my wife was a doctoral student, we decided to visit New York from Houston for the first time at Christmas. Without her knowing, I had purchased an engagement ring and planned to propose. I carried the ring in my pocket for two days, looking for the perfect spot, and ended up proposing in a quiet corner of Central Park. Her saying yes made it the best Christmas ever for me. Twelve years and two children later, New York at Christmastime remains a high point of our lives. **"**

Tony Beebe
Executive Vice President, Blue Ocean Drilling

Central Park. Illuminated trees appear to float in the Harlem Meer, the nearly ten-acre lake at the northeast corner of the park that the Central Park Conservancy restored in 1993.

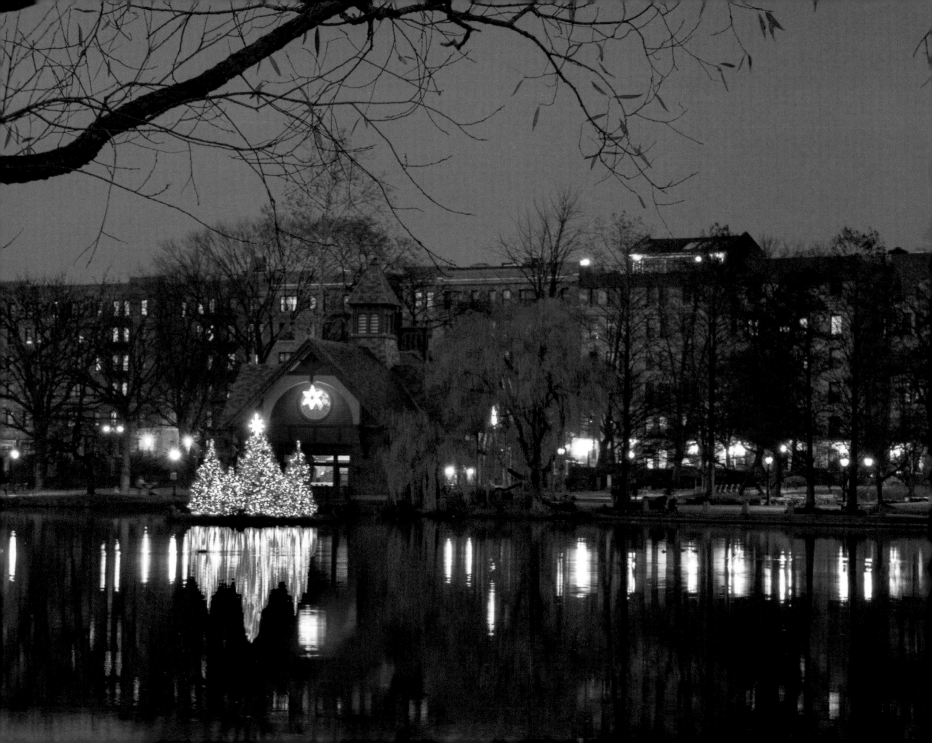

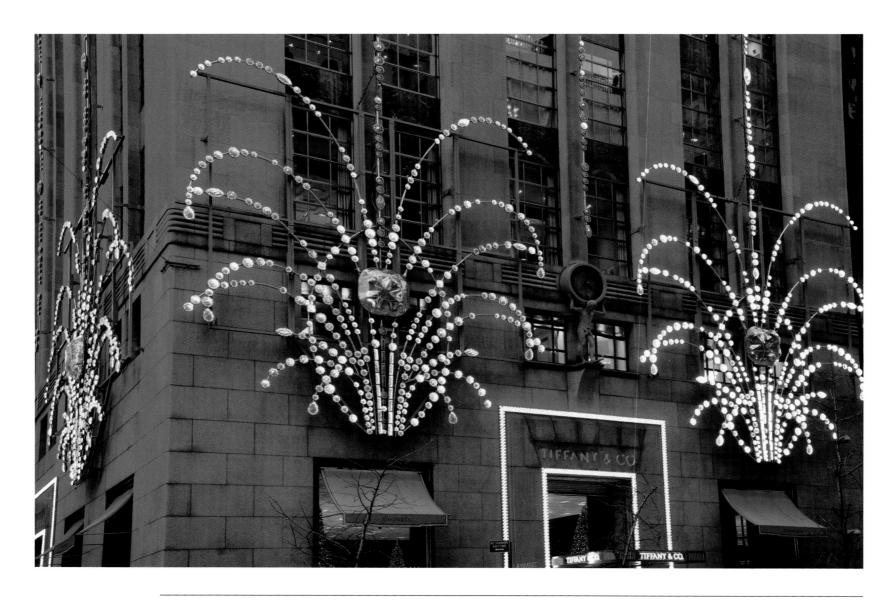

Tiffany & Co. At Christmastime, the exterior of the five-floor flagship store on Fifth Avenue at 57th Street is adorned with large jewel-like lights. Visitors flock to view its window displays that are like miniature, glittering stage sets. One depicts a wintry scene with a hand truck full of Tiffany's signature gift boxes. Another shows a Tiffany diamond engagement ring hooked by an ice fisherman.

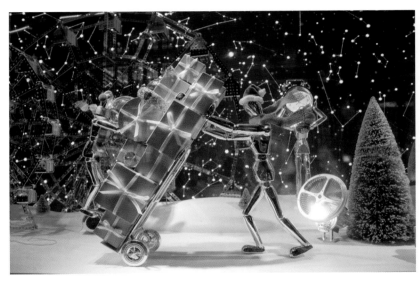
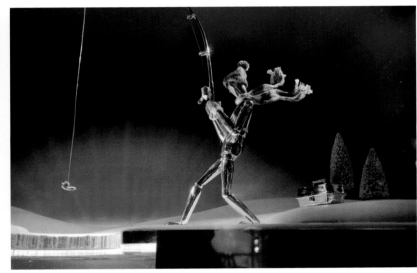

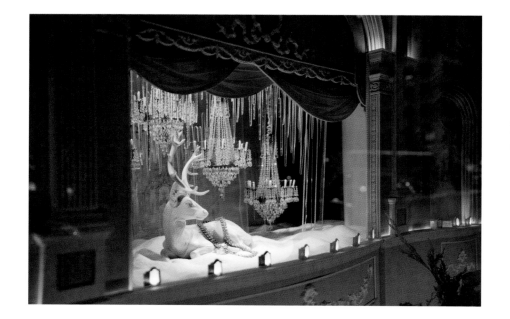

Tiffany Reindeer. A winter scene in a Tiffany window showcases a reindeer with a diamond necklace.

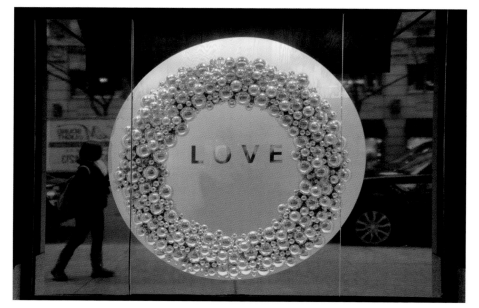

Velvet by Graham & Spencer. The word "Love" fills a window of the Madison Avenue boutique. The brand, founded in Los Angeles in 1997, has expanded to several boutiques in metropolitan New York, California, and London that feature women and men's fine casual clothing.

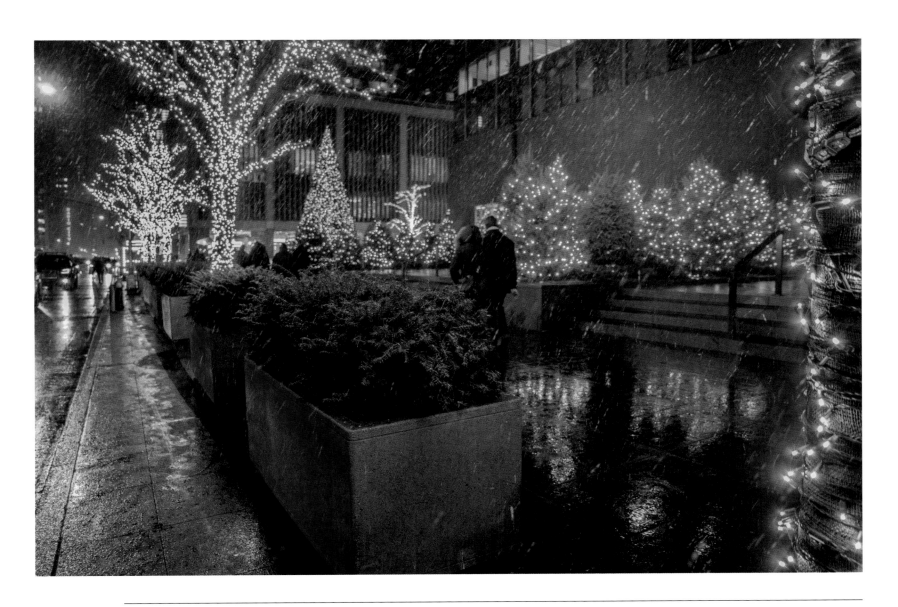

Neither rain nor melting snow on the city streets impede a romantic winter walk at night.

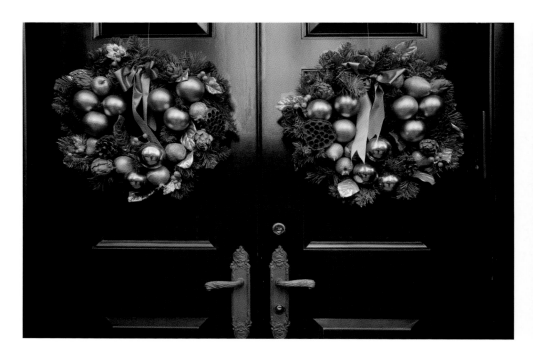

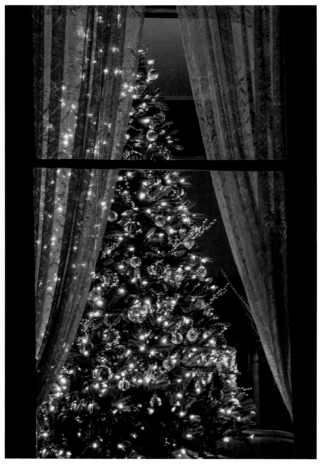

Wreaths and garlands. Private residences are decorated with a wide variety of wreaths on doors and twinkling garlands on stairwell banisters. Passersby can occasionally glimpse a shimmering Christmas tree inside.

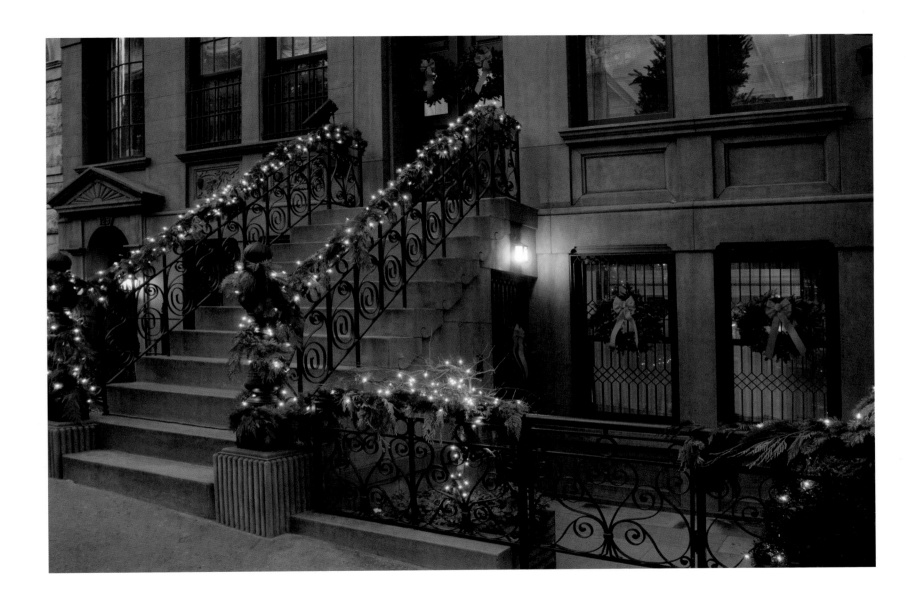

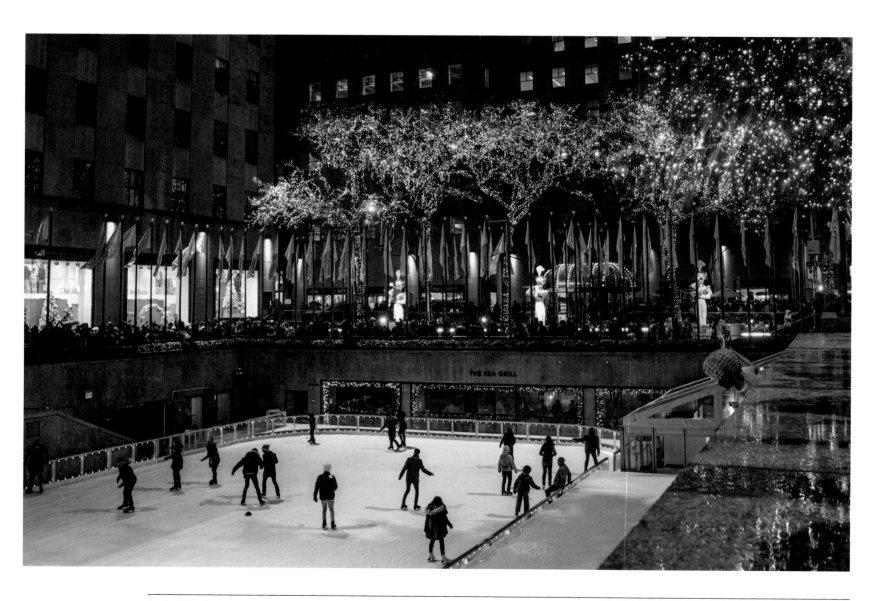

Rockefeller Center Skating Rink and Plaza. New Yorkers and visitors from all over the world enjoy skating at the rink below the famous Christmas tree. More than 200 gold and silver flags glisten on the plaza.

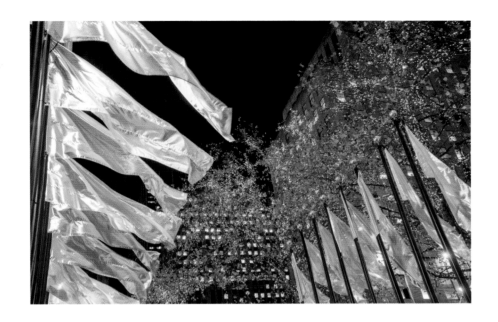

["]We share the joy of Christmas with family, inspired by our Italian heritage. For a dozen years, all twenty-eight of us set aside one day that starts at eight o'clock in front of Mimi and Poppi's house. A bus awaits us, stocked with hot chocolate and munchies, and our youngest grandchildren sing Christmas carols all the way to the city. First stop is the Ronald McDonald House to bring gifts and a check for families in need. Back on the bus to the 11:30 Radio City Rockettes show. Then to 'Rock' Center to photograph the big tree and watch the skaters. Next stop, craft shops in Bryant Park for a keepsake of the day. Finally, dinner at a great Italian restaurant. There we hold hands, say grace, and thank God for a wonderful day that ends with a song-filled trip home. ["]

Joseph R. Lagana
CEO, US Information Systems

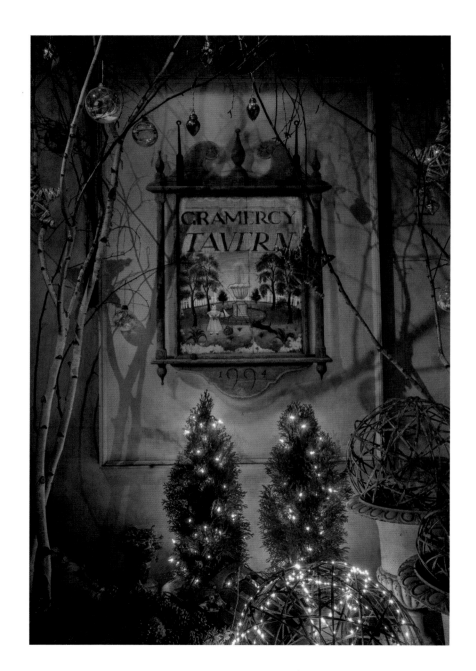

Gramercy Tavern. A charming nook welcomes guests to the rustic but elegant restaurant, owned by noted restauranteur Danny Meyer, that prides itself on produce from local farms and the nearby Greenmarket.

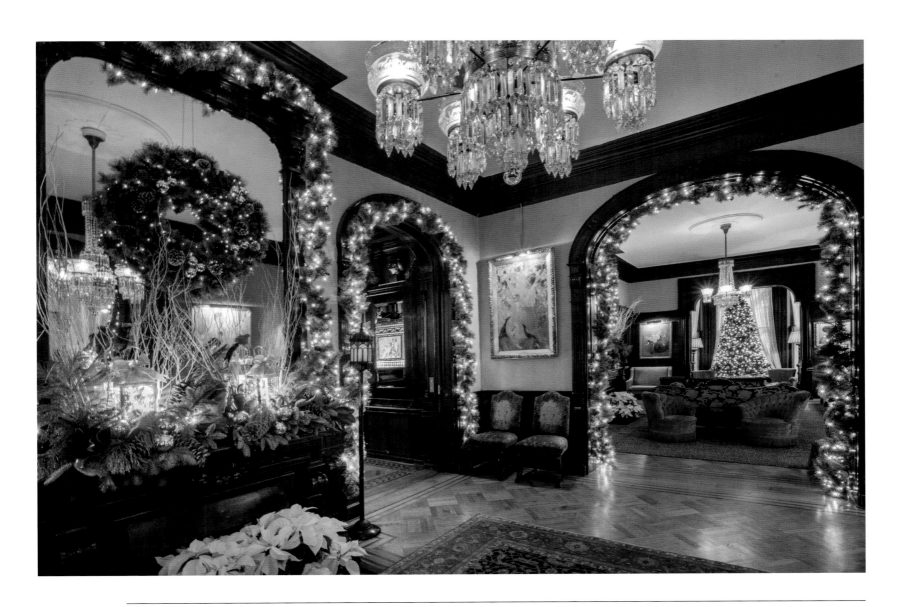

National Arts Club. The private club on Gramercy Park is elegantly lit and decorated at Christmastime. Formerly the mansion of Samuel J. Tilden, twenty-fifth governor of New York State, its mission is to foster and promote interest in the arts. Its members have included prominent collectors, artists, literary figures, and architects.

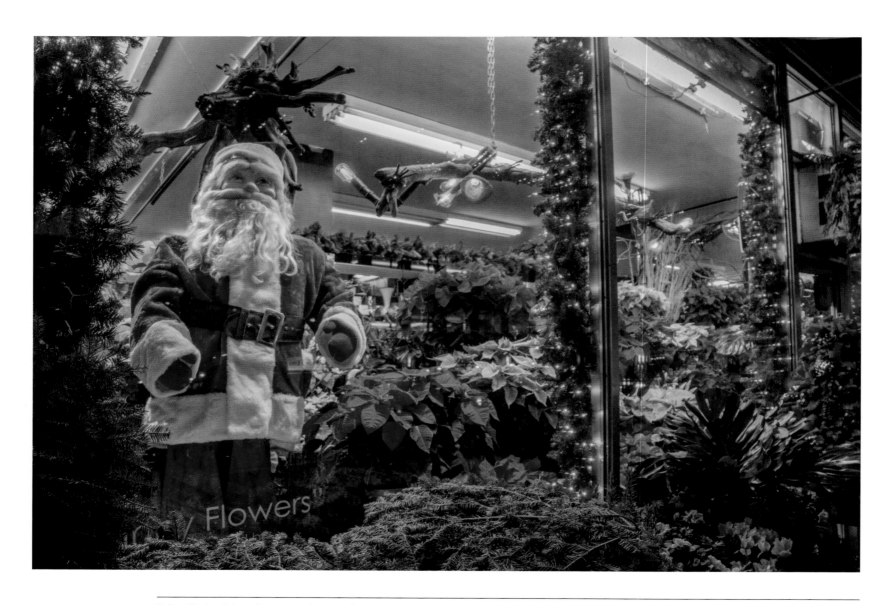

Fellan Florist. Poinsettias surround a giant Santa in the windows of the floral design shop on 65th Street that has been a stalwart presence on the Upper East Side since it was established in 1927.

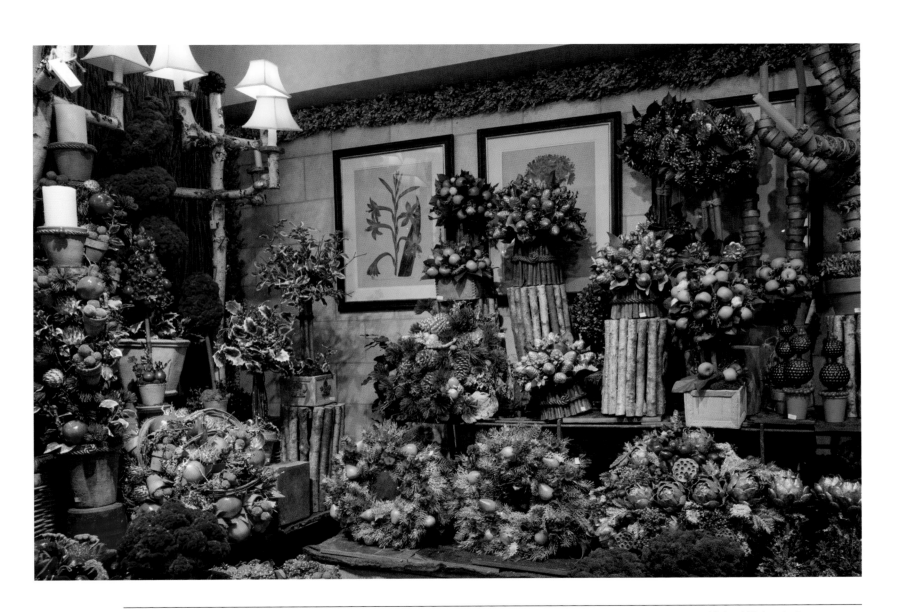

Lexington Gardens. A hallmark of the shop is its ornately crafted seasonal dried flower arrangements by designer and co-owner Michael Walter. Lexington Gardens also carries unusual gifts and decorative accessories for the home and garden.

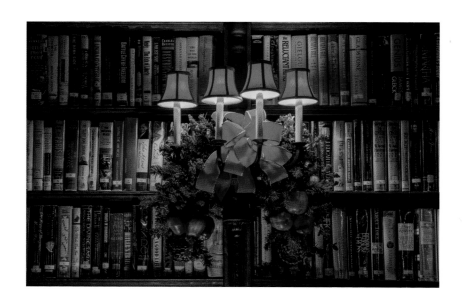

"I love all of Christmastime, from after Thanksgiving to New Year's Eve – the smells, the sounds, the colors. I adore the aroma of cinnamon sticks and cloves that simmer on my stove. And what could be better than the sound of Christmas carols? They played all Christmas day at home on Staten Island, and I've continued the tradition ever since I moved to Manhattan at age twenty-four. I love the little white twinkle lights and Christmas trees with all blue lights. My own tree is filled with antique ornaments, glass icicles, and the Christmas star that topped my parents' tree. I just love Christmas in New York! **"**

Mario Buatta
Interior Designer

Lotos Club. A candlestick wall sconce is one of several mounted against the recessed bookshelves in the library of the Lotos Club. Since 1947, the private social club has occupied a grand mansion built in 1900 in the French Second Empire style.

A Christmas tree sparkles in a townhouse living room that looks to a backyard garden.

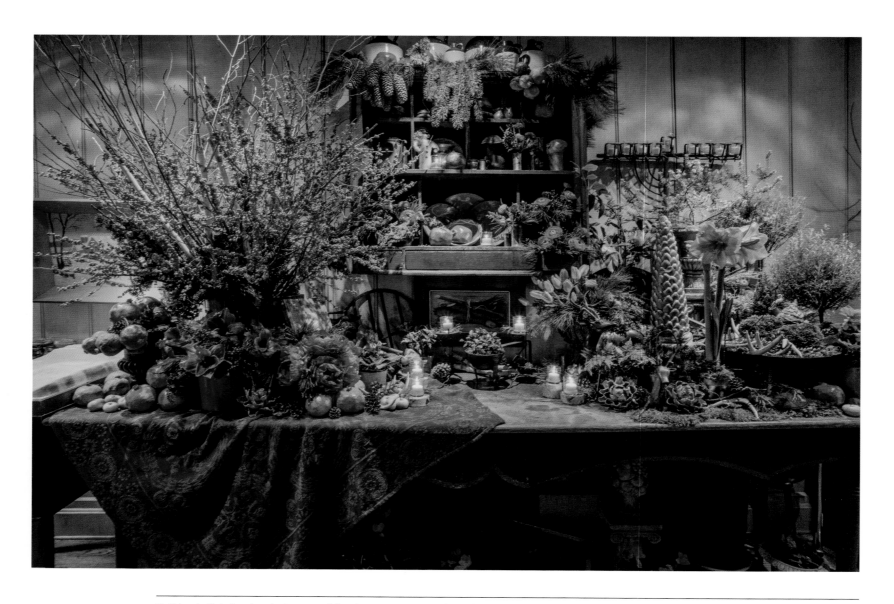

Holiday buffet. An abundant seasonal floral arrangement on a large buffet table, by Gramercy Tavern's florist Roberta Bendavid, whets the guests' appetites.

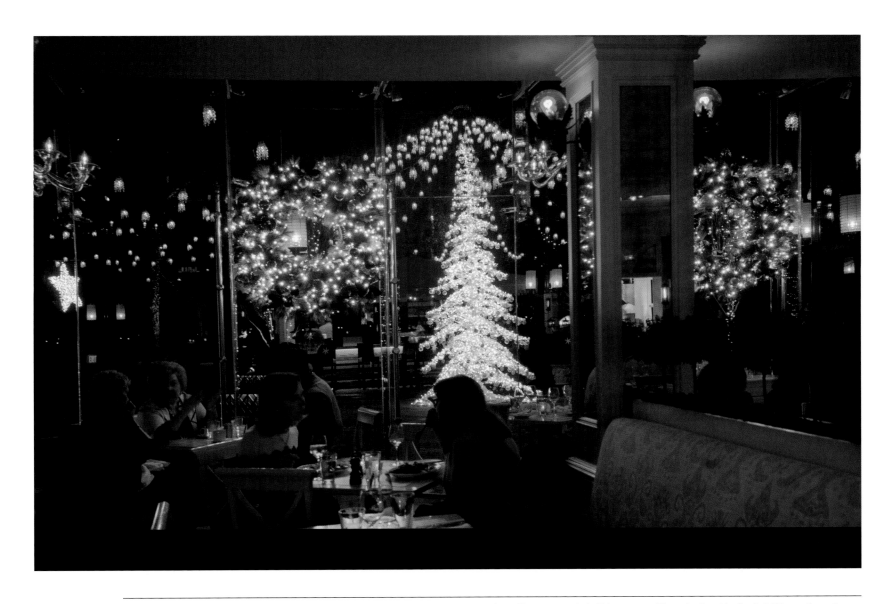

Romantic dining. Tavern on the Green in Central Park is one of many restaurants that offer a romantic holiday venue. Diners look out to the twinkling adjacent garden.

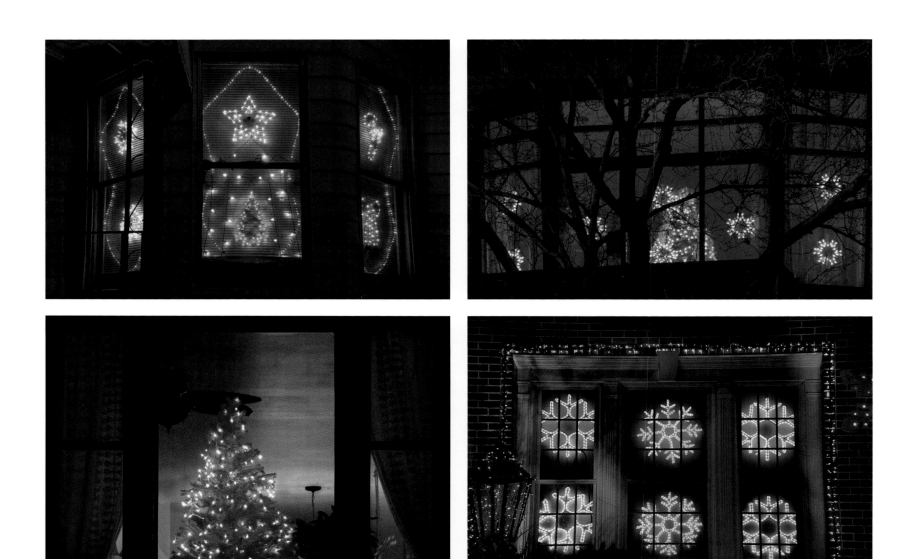

Windows of private residences are imaginatively lit and decorated with stars, snowflakes, and wreaths.

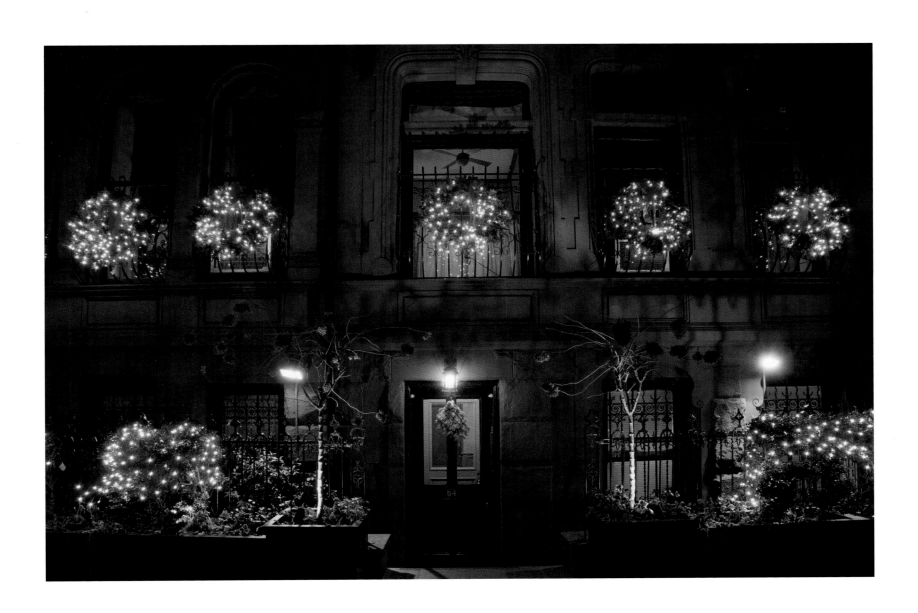

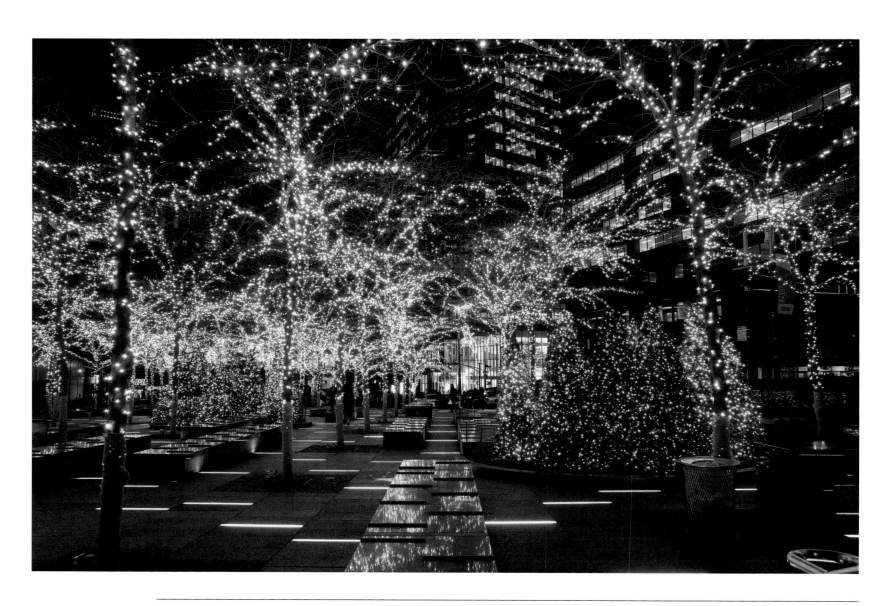

Zuccotti Park. Located in the Financial District, the park is illuminated with thousands of white lights built into the ground and wrapped around the trees. Formerly Liberty Plaza Park, it was badly damaged in the World Trade Center attacks and used as a staging area for the recovery efforts. The park reopened in 2006, after renovation by Brookfield Properties, which had purchased the park and renamed it Zuccotti Park in honor of the then-chairman of Brookfield Properties.

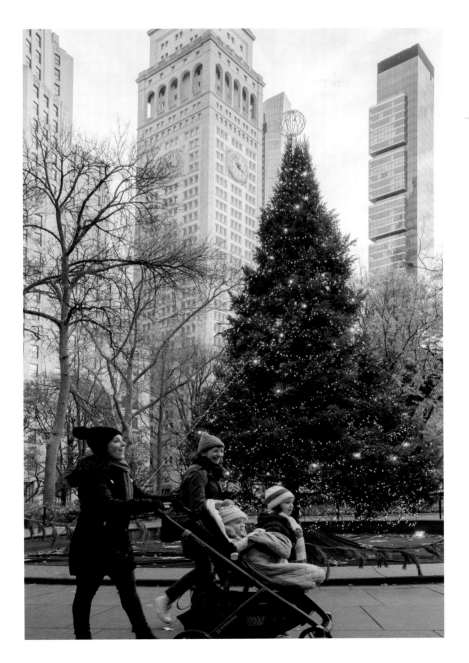

Madison Square Tree of Light. The tree lighting tradition has continued in the seven-acre Madison Square Park since 1912, when it was the site of the nation's first Christmas tree in a public park.

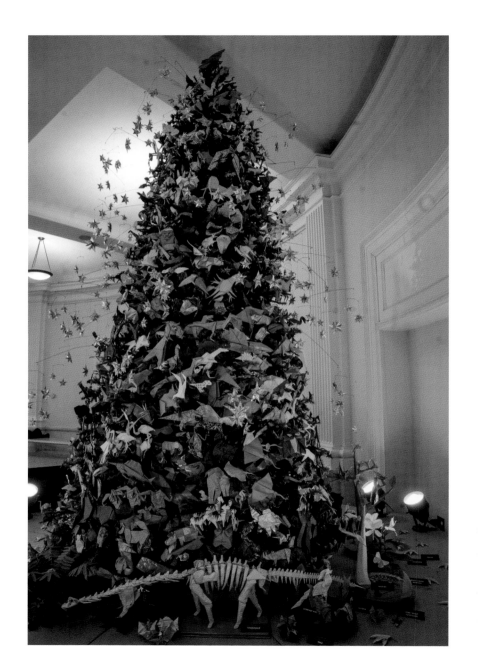

Origami Holiday Tree. Origami Dinosaurs Among Us, with folded papers inspired by the American Museum of Natural History exhibition and collections, exemplifies a tradition of more than forty years. The thirteen-foot tree, created in partnership with OrigamiUSA®, is decorated with more than 800 hand-folded models created by national and international origami artists.

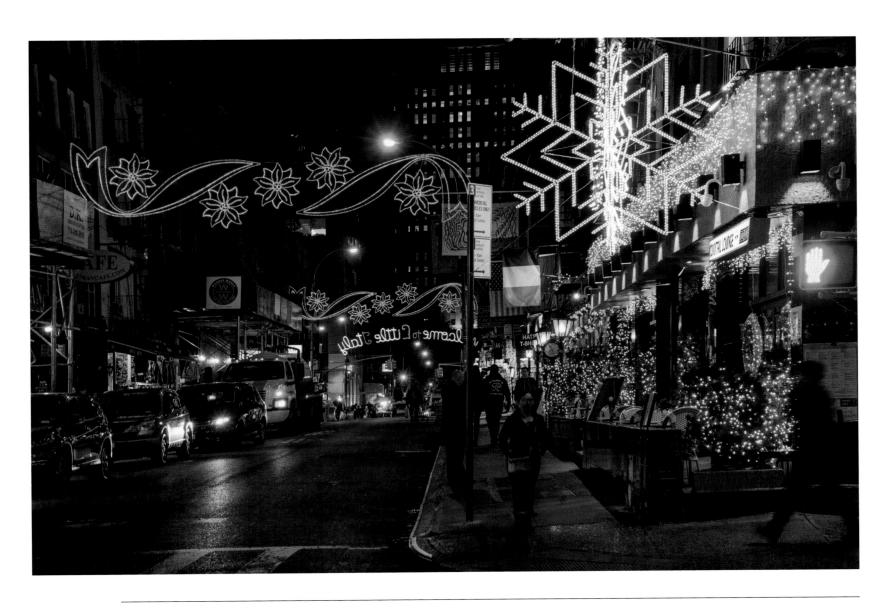

Little Italy. The streets of Little Italy, once known for its large Italian-American population, are replete with Italian restaurants that are profusely lit and decorated at Christmastime, particularly on Mulberry Street, the neighborhood's main thoroughfare.

Winter rain and snow cast a romantic mood in the city's streets, gardens, and parks.

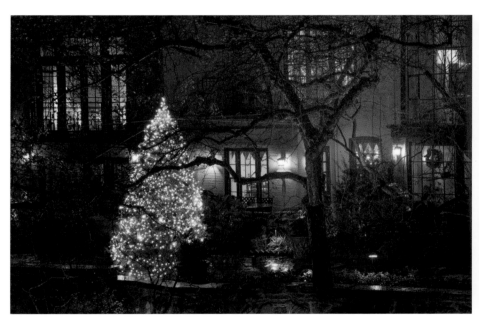

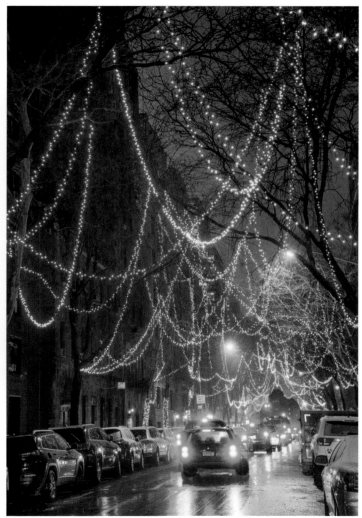

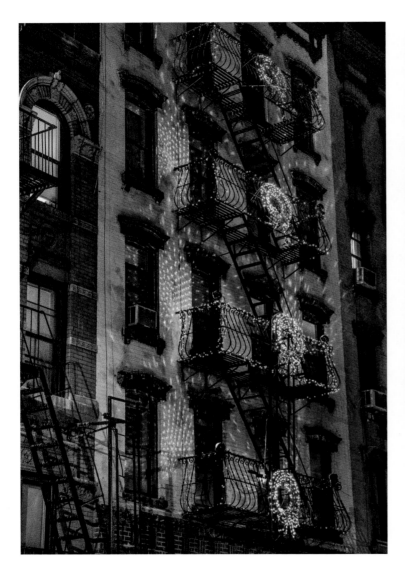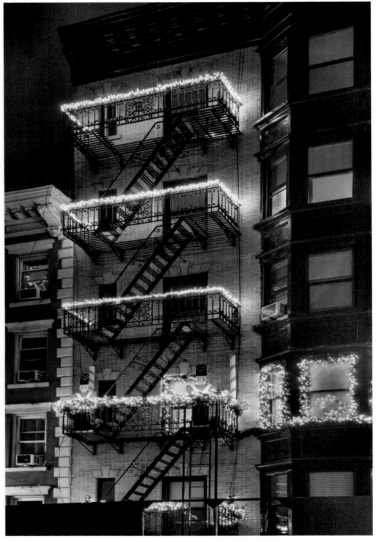

Looking up, one can occasionally chance upon a decorated fire escape, like the one in Little Italy (right) or the one on the lower East Side (left).

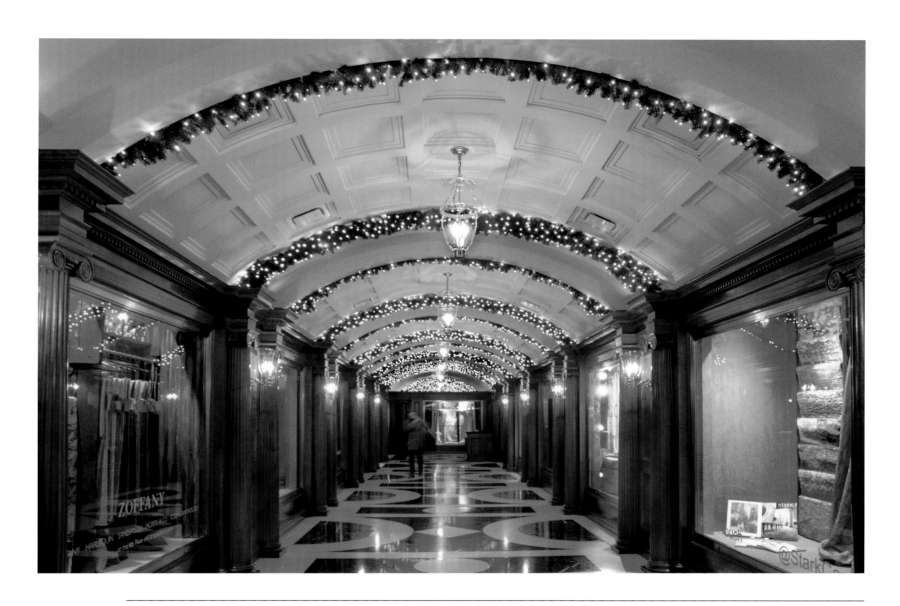

Decoration & Design Building. The grand lobby of the commonly called D&D building is simply but elegantly attired for the holiday. It is home to more than 130 showrooms that represent more than 3,000 manufacturers of fabric and furnishings for residential and commercial interior design. Located on Third Avenue at 59th Street, it is open exclusively to the trade.

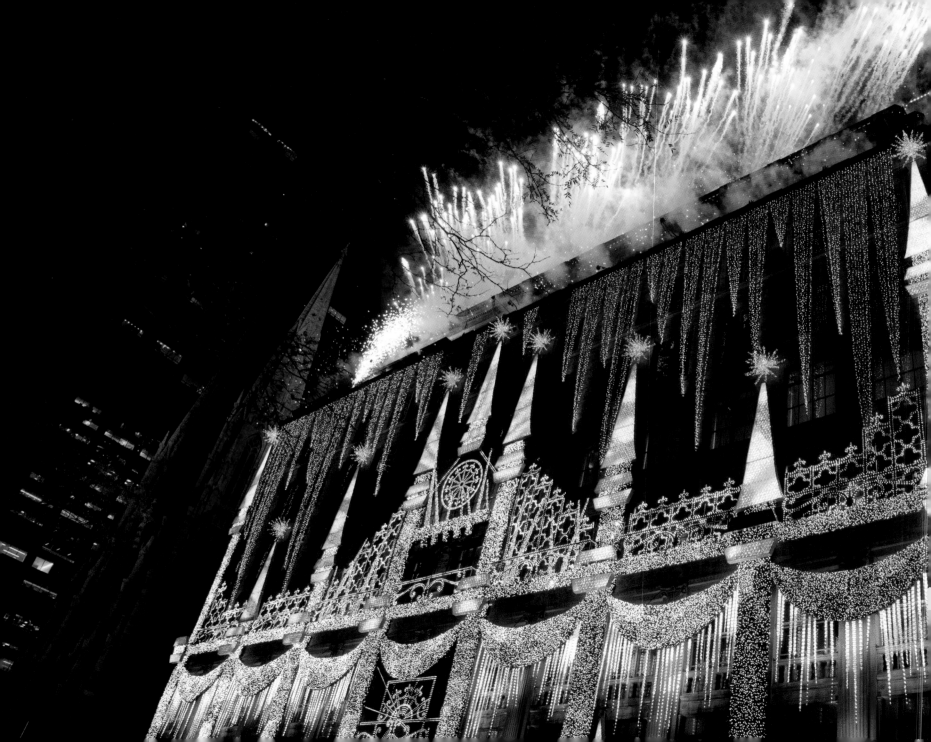

Holiday Light Show. The holiday windows at Saks Fifth Avenue are unveiled with a ten-story, high-tech extravaganza across the building's Fifth Avenue façade that culminates with a Grucci fireworks display on the roof. The theatrical light show at the luxury department store across from Rockefeller Center changes colors and sound in ten-minute intervals throughout the holidays. It was created in partnership with American Christmas, Inc. and Chris Werner Design.

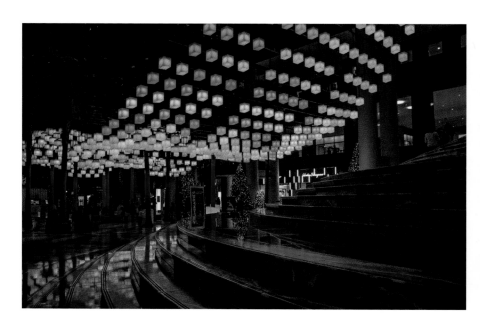

Brookfield Place. The Grand Staircase in the luxury shopping and office complex across from the World Trade Center reflects Luminaries, interactive light shows of alternating colors on the atrium canopy. Some are linked to Christmas songs. Visitors are invited to make a wish by touching one of the glowing Wishing Stations.

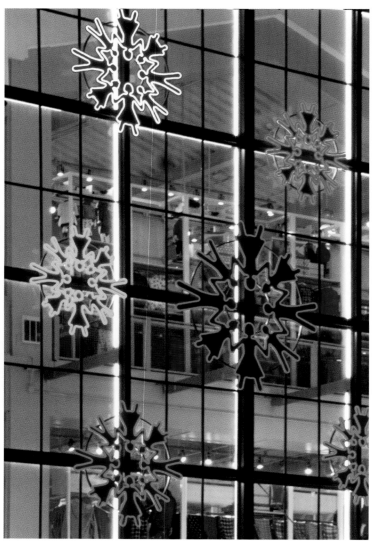

Old Navy. The American clothing and accessories retail store at Herald Square is lit with colored snowflakes, graphically formed by children holding hands in a circle.

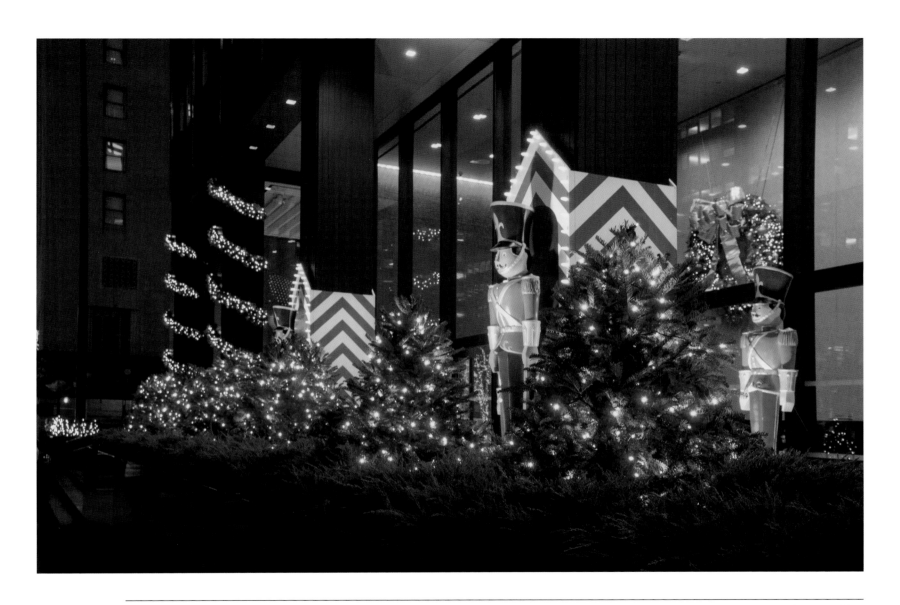

299 Park Avenue. Eight-foot-tall toy soldiers, mounted on drums and separated by blue-lit Christmas trees, stand in front of the Park Avenue building between 48th and 49th Streets.

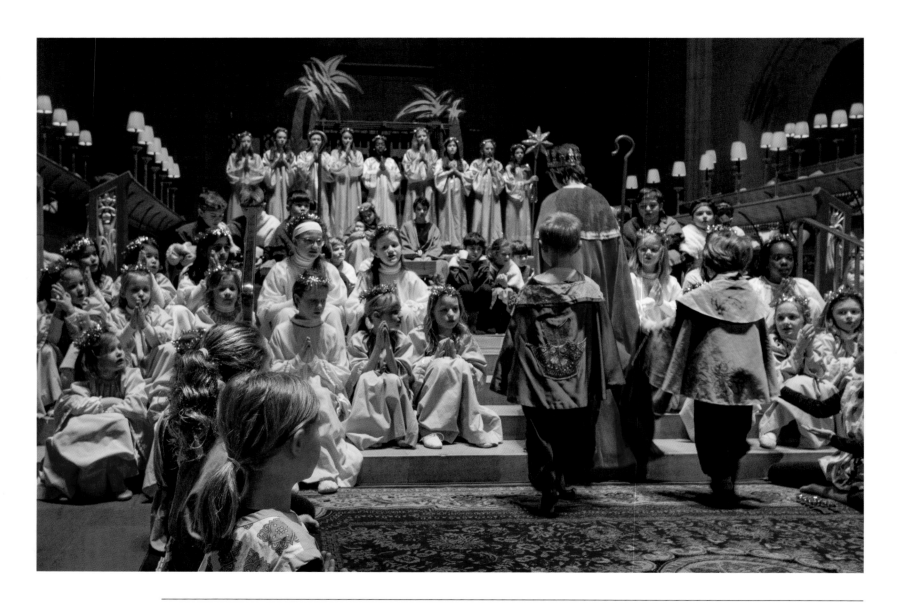

Church of the Heavenly Rest. Crowds gather to see more than ninety children, along with live animals, participate in the Christmas Eve pageant, a holiday tradition for decades at the Church of the Heavenly Rest on Upper Fifth Avenue. The 1929 limestone church, with vibrant blue stained-glass windows, is decorated with wreaths, garlands, and lights.

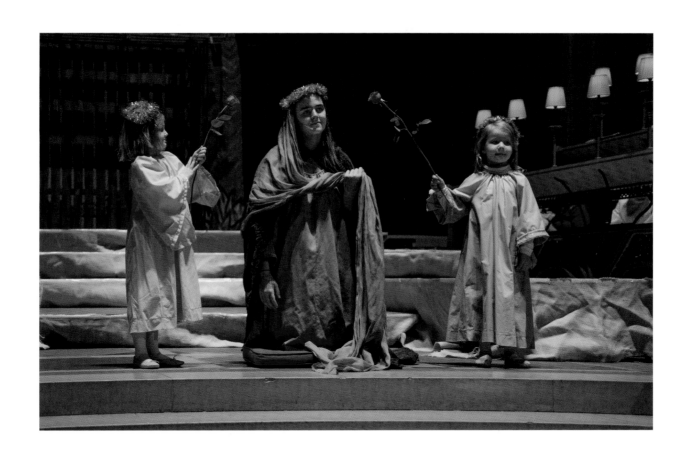

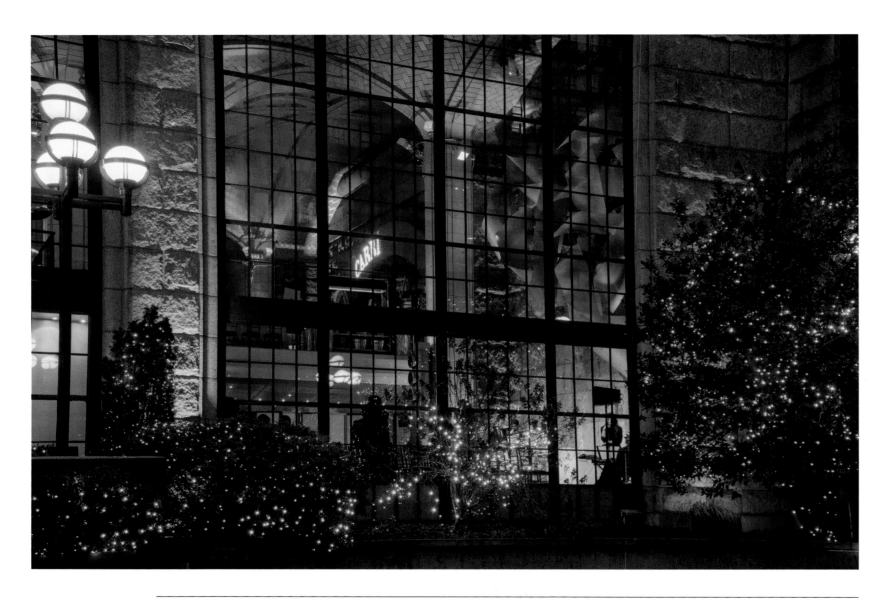

Guastavino's and 583 Park Avenue. Two large event venues are extravagantly lit for the holidays. Guastavino's (above), directly under the 59th Street Bridge, was designed by Spanish architect Rafael Guastavino in 1909, and offers a fine example of his famous Catalan vaulted ceilings with arches that soar thirty-five feet high. 583 Park Avenue at 63rd Street (opposite), a New York City landmark, was designed by Delano & Aldrich in 1923, and was recently modernized to serve as a major venue for meetings, luncheons, and other events.

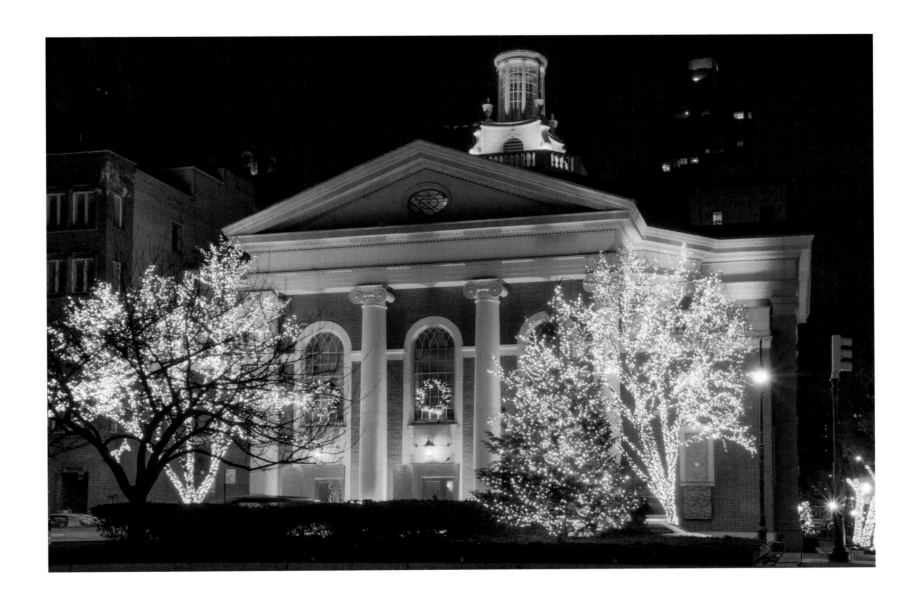

Dyker Heights. Crowds flock by car, tour bus, and subway to the residential neighborhood in southwestern Brooklyn to view more than 250 elaborately decorated houses and front yards. Homeowners create some of the decorations; other displays are the work of professional lighting or decorating companies.

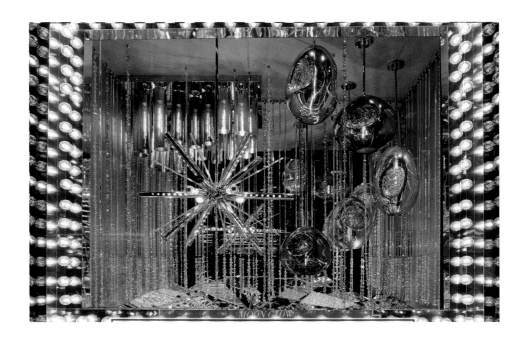

"New York is the greatest city in the world and at its best during the Christmas holiday season. The streets are all aglitter, the bodegas lined with fresh trees, the stores both big and small put on a grand show with their decorations and magical window displays. There is excitement in the air that one feels just by walking down the Avenues. "

Jack Hrushka
Executive Vice President of Creative Services, Bloomingdale's

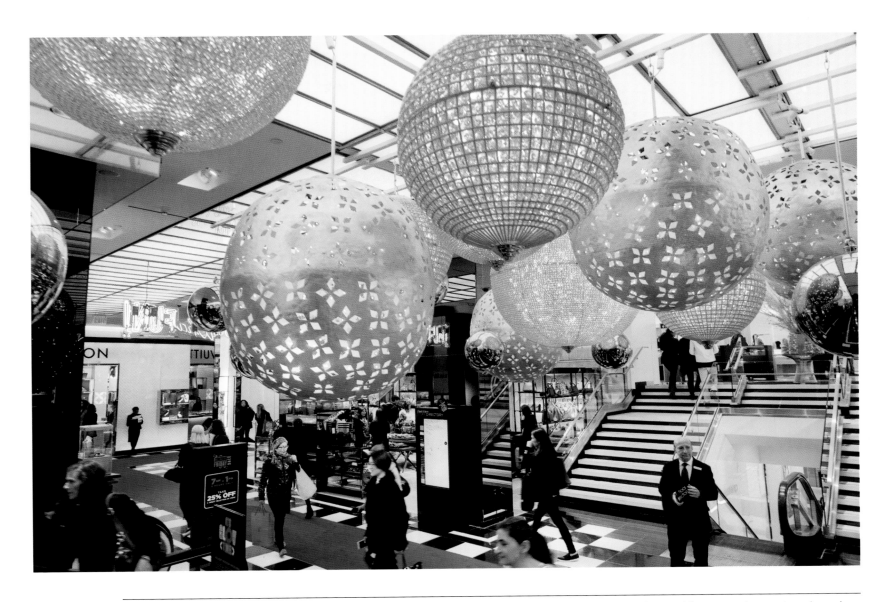

Bloomingdale's. Several dozen gold, silver, and crystal balls hang from the ceiling of the flagship department store's ground floor, conveying an atmosphere of drama and elegance through the main passageway from Lexington to Third Avenue. Each year a different holiday window theme captivates passersby. *Moonglow,* by glass artist Abby Modell, was featured in 2016 with the theme of light. Preparation begins nine months before the windows are unveiled.

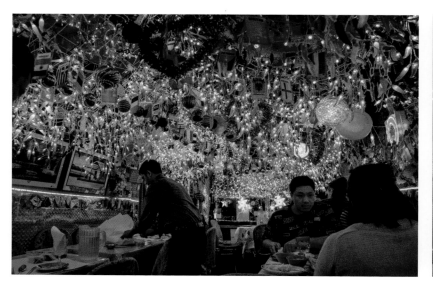

Molly's, Milon, and Rolf's. These three dining venues have over-the-top holiday decorations and draw crowds that wait in line to enter. Two in the Gramercy neighborhood are Molly's (above right), an intimate Irish pub with a wood-burning fireplace, and Rolf's German Restaurant (opposite), which is decorated for Christmas year-round. Milon (above left), an Indian restaurant on the Lower East Side, has equally opulent holiday décor.

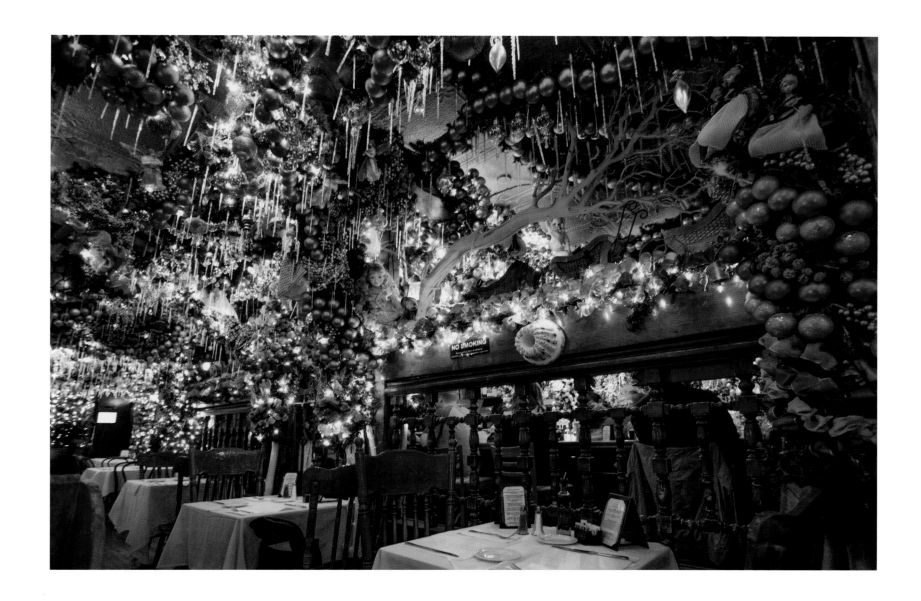

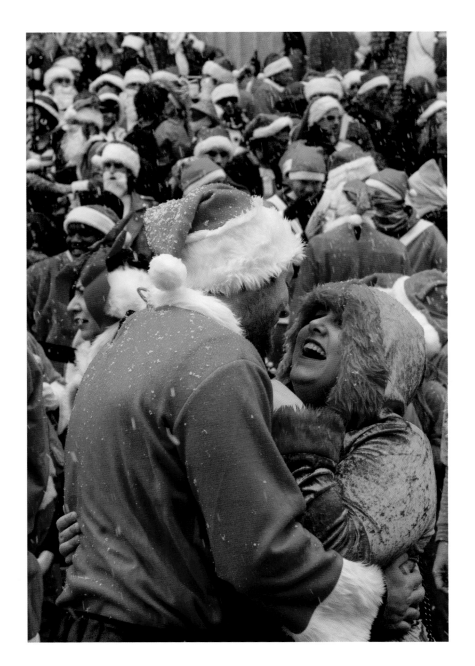

SantaCon. Dressed as Santa Claus and other Christmas characters, New Yorkers and out-of-towners convene in mid-Manhattan on a designated December day each year. Participants in the increasingly large event flood the streets and subways in search of holiday cheer, frequently embark on a festive bar crawl to participating pubs.

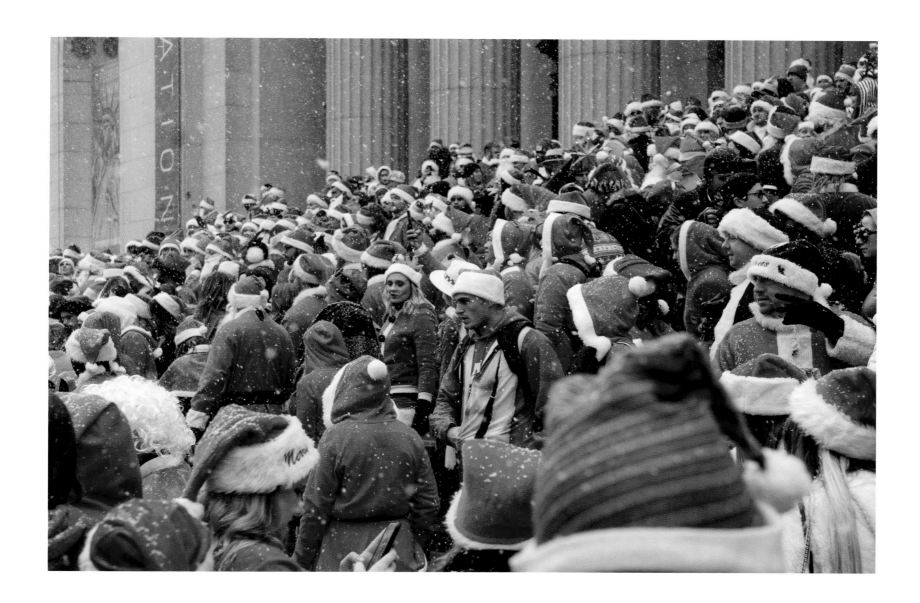

photo: 2016

Macy's. The aqueduct-like bridge, topped with colorful holiday gift boxes in 2016, is one of many imaginative interior displays that have enchanted shoppers at Macy's Herald Square department store. Their holiday windows draw more than 10,000 people who pass them per hour.

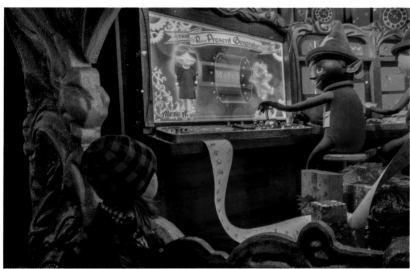

photo: 2016

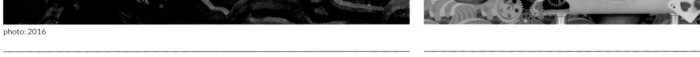

photo: 2016

Macy's. A 2016 window depicted Santa's Communications Station, a fantasy pinball machine through which Santa makes his gift-giving list and matches it to children around the world. Macy's windows salute its "Believe" letter-writing campaign that raises funds for Make-a-Wish®, the organization that grants wishes to children with life-threatening medical conditions.

Barneys. Holiday windows at the luxury retailer on Madison Avenue focus on the theme of Love, Peace, and Joy, with each window created by a different artist. The Madison Avenue store is well-known for its fine leather goods, clothing collections by traditional and up-and-coming designers, and upscale restaurant, Fred's.

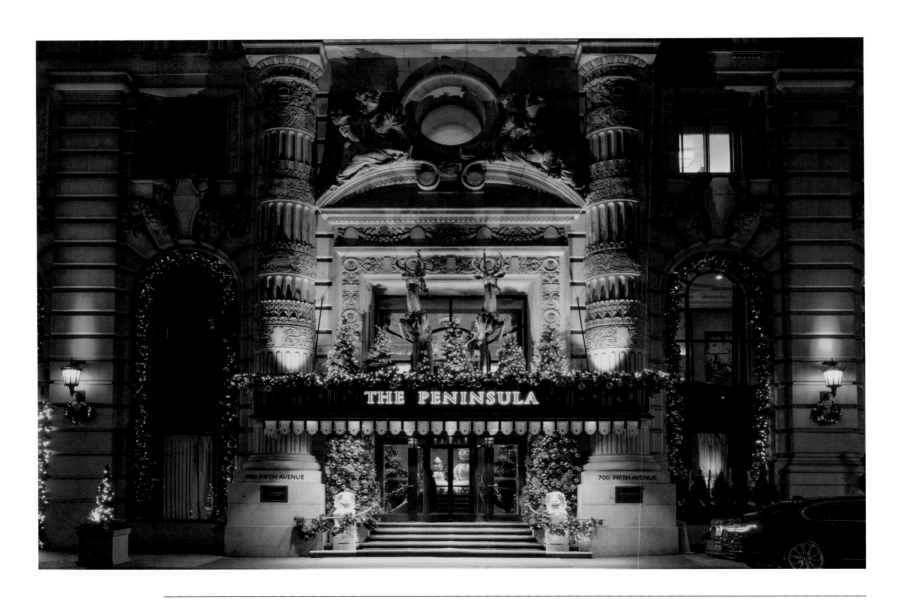

The Peninsula New York. At Fifth Avenue and 55nd Street, the elaborate neo-classical-style façade of this 1905 landmark hotel is radiant during the holiday. Both the indoor bar and the outdoor heated terrace of the Salon de Ning Rooftop Bar are popular in winter.

The St. Regis New York. An emblem of New York luxury for decades, having served impressive lists of celebrities and dignitaries, the St. Regis hotel was built by the American financier John Jacob Astor in the French Beaux-Arts style. Its King Cole Bar of the St. Regis is a fashionable destination for cocktails and dining.

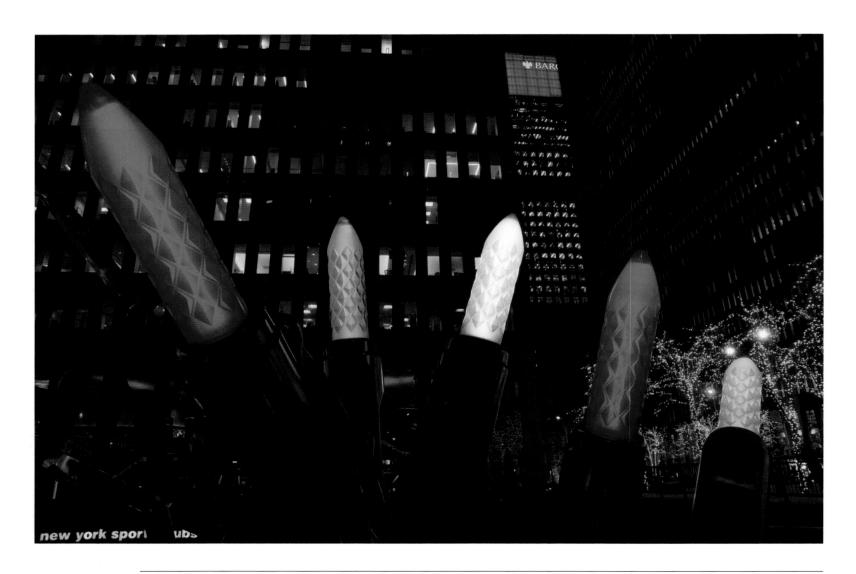

1221 and 1251 Avenue of the Americas. Even the most rushed passersby on Sixth Avenue in midtown can't help but pause in front of two exciting holiday installations. Outside 1221 is a twenty-five-yard-long display of thirty-one seven-foot-tall light bulbs in vibrant colors developed by American Christmas, Inc.

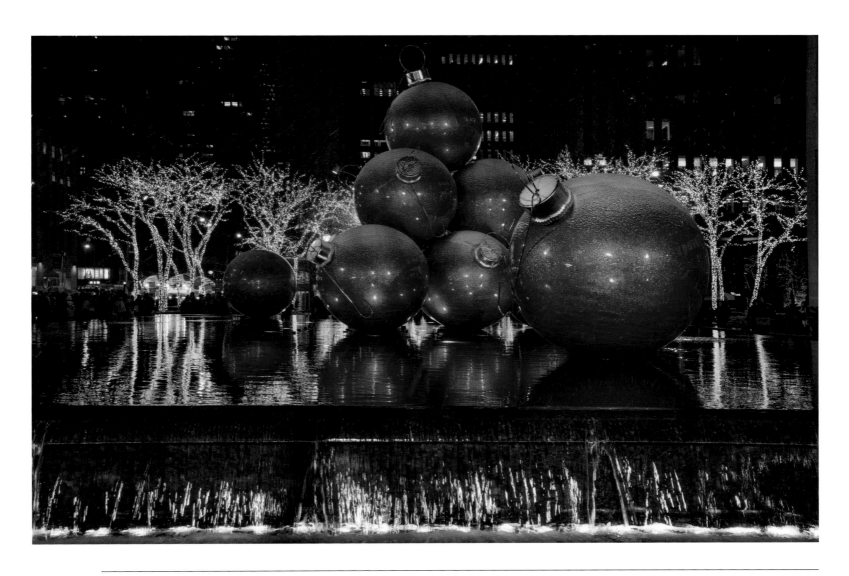

At 1251 Sixth Avenue, giant red Christmas bulbs made of steel-reinforced fiberglass, with chrome-finished caps and hooks, make a dramatic display in the reflecting pools. This installation was conceived by Venue Arts and inspired by the work of sculptor Claes Oldenburg, whose public art replicates everyday objects.

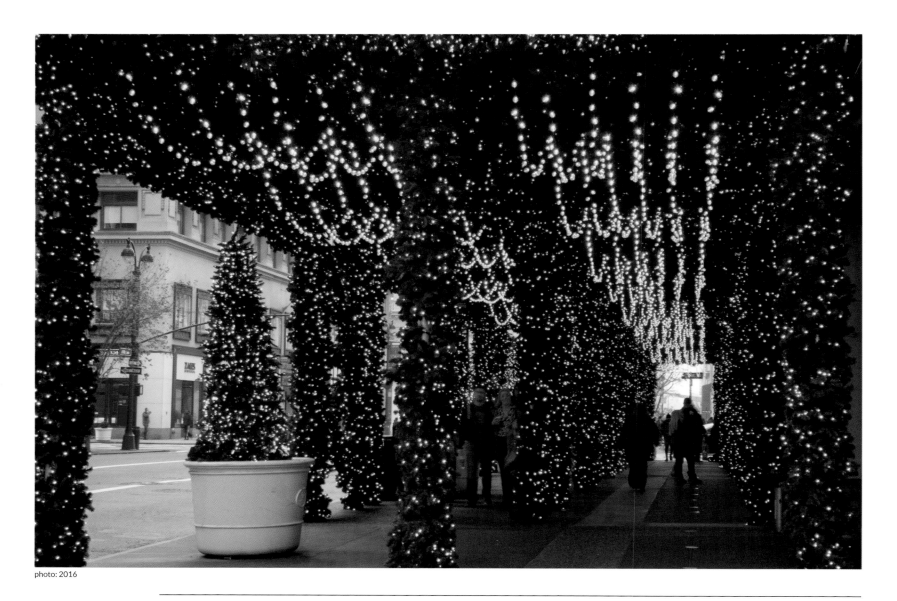

photo: 2016

Holiday scaffold. A cleverly modified scaffold becomes a sparkling canopy at the entrance to Lord & Taylor. For several years, the construction scaffolding was outfitted for the Christmas holiday with more than 500,000 LED lights and music.

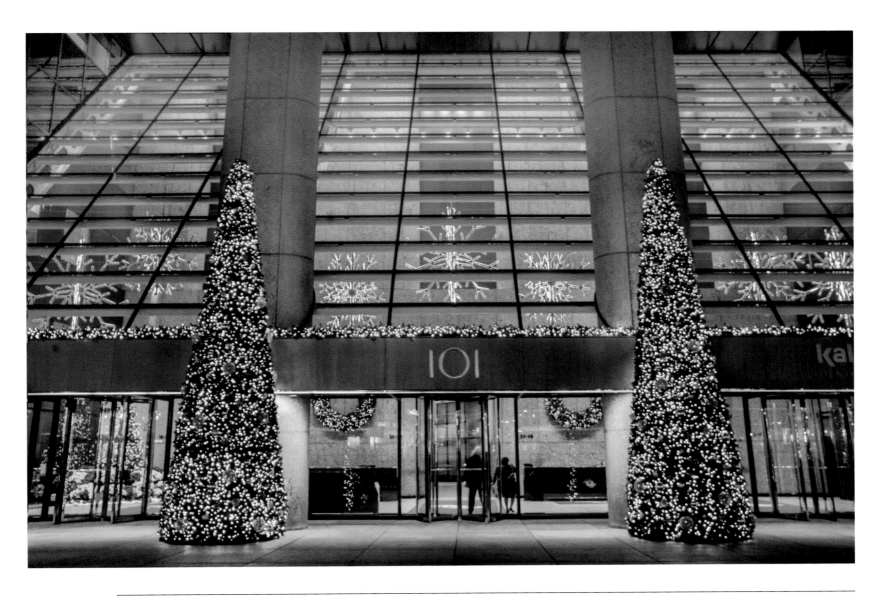

101 Park Avenue. Glistening with reflective glass at 40th Street, 101 Park Avenue is elegantly decorated with distinctive trees and wreaths. The forty-nine-story office building, also known as the Kalikow building, opened in 1982, and has been used as the site for many films.

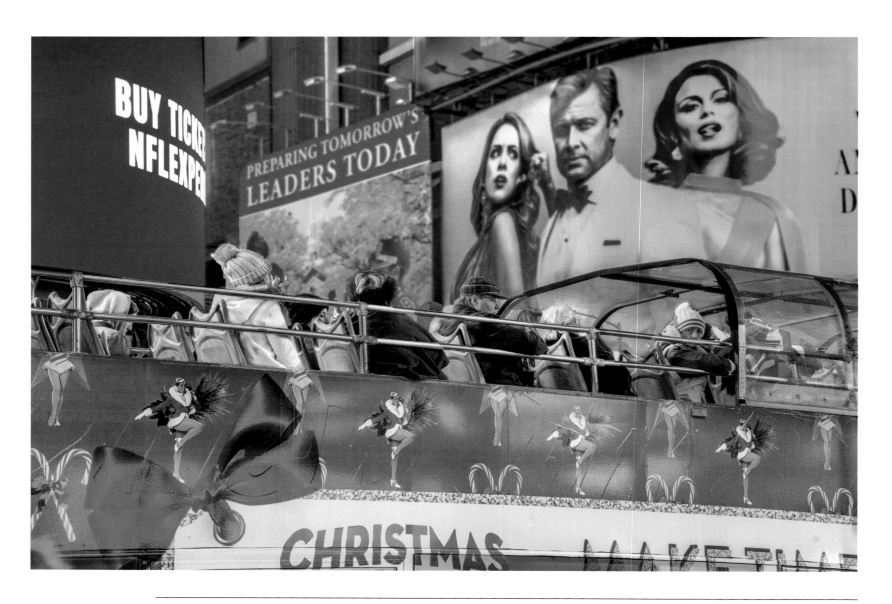

Tours by bus. Bus tours are an excellent way to see the Big Apple at Christmastime, and there's one for every preference: daytime or nighttime, hop-on and hop-off, single or multiple-day tickets, and themed tours. They are offered by Gray Line CitySightseeing New York, pictured above; The Ride; CitySights NY; and other companies. All make stops at Times Square.

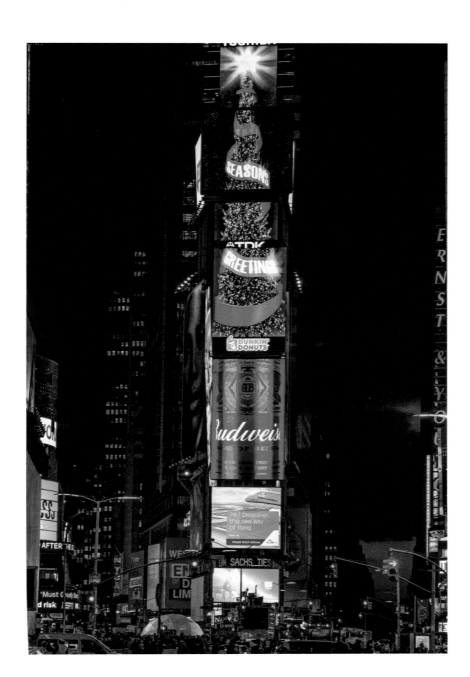

Times Square. One of New York's iconic images is the dazzling, animated neon and LED signs on Broadway from West 42nd to 47th Streets. An estimated one million people gather in the bustling commercial intersection and tourist destination to watch the ball drop at One Times Square as midnight nears and the clock strikes twelve, ushering in the new year.

Donahue's and Paddy McGuire's. Two popular Irish venues that are especially warm and convivial in the winter cold are Donahue's (above), the popular pub-restaurant on the Upper East Side, and Paddy McGuire's Ale House (opposite) near Gramercy Park that offers an active bar as well as televisions and pool tables.

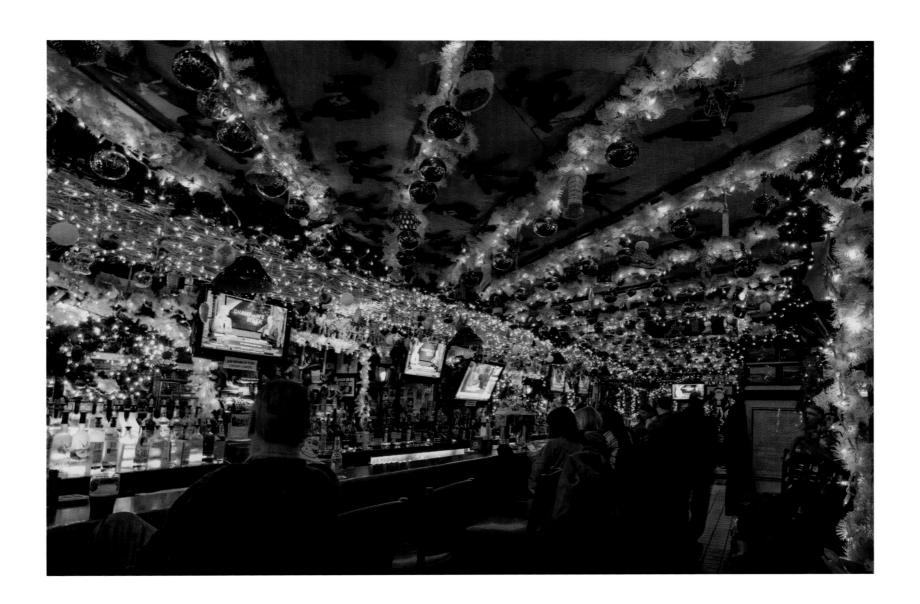

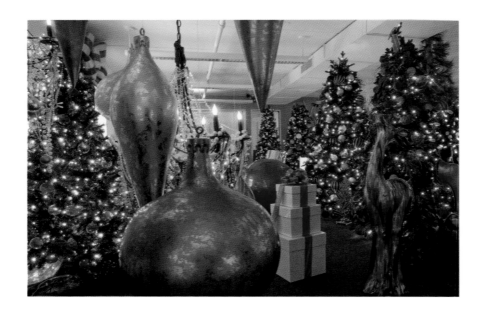

" Every day for us is Christmas. We spend 365 days of the year designing, planning, and installing decorations for luxury boutiques, hotels, and skyscrapers. Having traveled the world to look at unique Christmas decoration, I'm convinced there's no city more dazzling than New York during the winter holidays. "

Fred Schwam
CEO, American Christmas, Inc.

American Christmas, Inc. The showroom of the company's 110,000-square-foot facility gives a mini taste of the lights, Christmas trees, and imaginative decorations designed, assembled, and installed by the firm's sixty-five full-time and 125 seasonal personnel. Among the companies that sell and design commercial holiday decoration, American Christmas, Inc. has substantial impact on New York City, creating decorations from the cadets that line the ice rink at Rockefeller Center to the tree on the Radio City marquee.

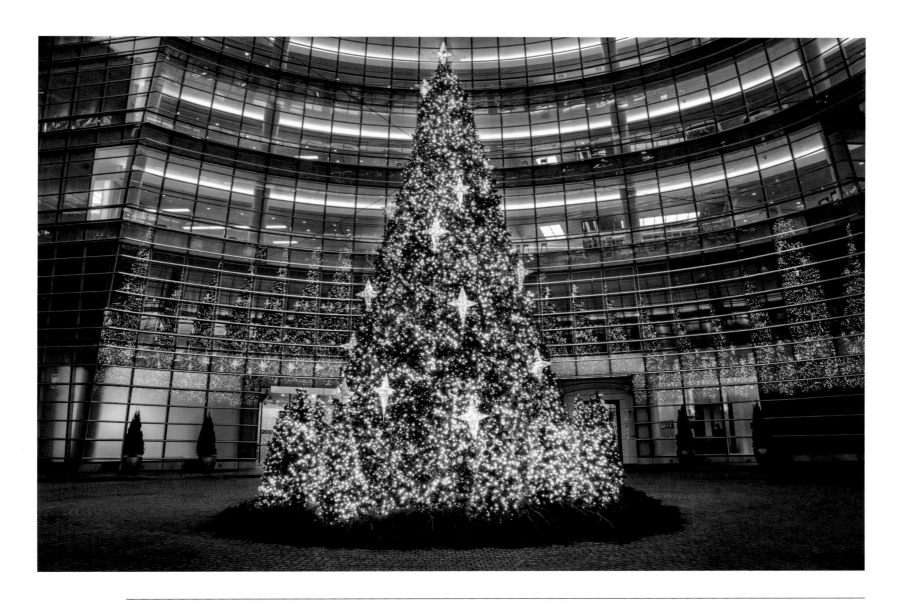

731 Lexington Avenue. This building, also known as the Bloomberg Tower, has a forty-foot tree with 70,000 LED lights, thirty floating stars, and twenty-one decorative trees at the base. Designed and installed by Holiday Image LLC, the tree serves as the centerpiece of the multi-colored illuminated glass atrium at holiday time. The block-long building between East 58th and 59th Streets, designed by Cesar and Rafael Pelli, is the world headquarters of Bloomberg LP, the financial services company. It also contains stores, restaurants, and luxury residences.

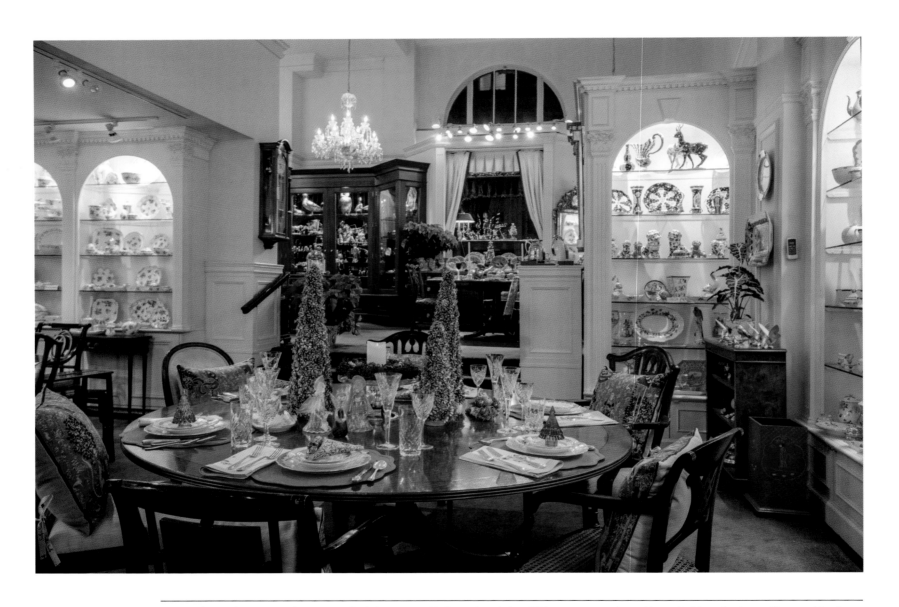

Scully & Scully. The two-story boutique on Park Avenue at 60th Street, founded in 1934, is a treasure chest of luxury holiday gifts, home décor, and furniture. The Christmastime presentation on street level features table settings with Herend porcelain, hand-painted linen napkins, glass holiday objects, and medieval tapestry pillows from the store, while surrounding cases are filled with crystal, sterling silver, and fine china.

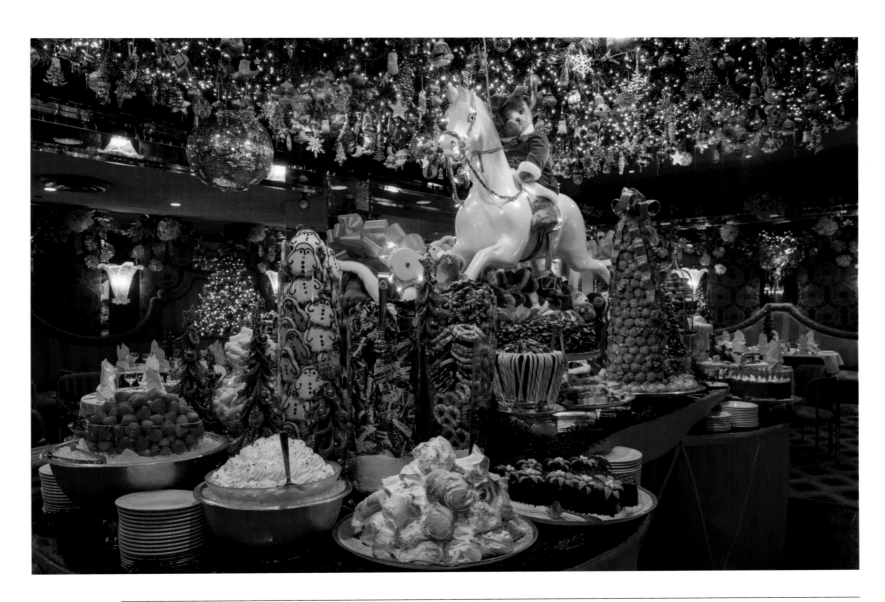

Holiday feasts. A delectable dessert table at Doubles, the private club in the Sherry Netherland Hotel, is one of New York's special holiday luncheon venues.

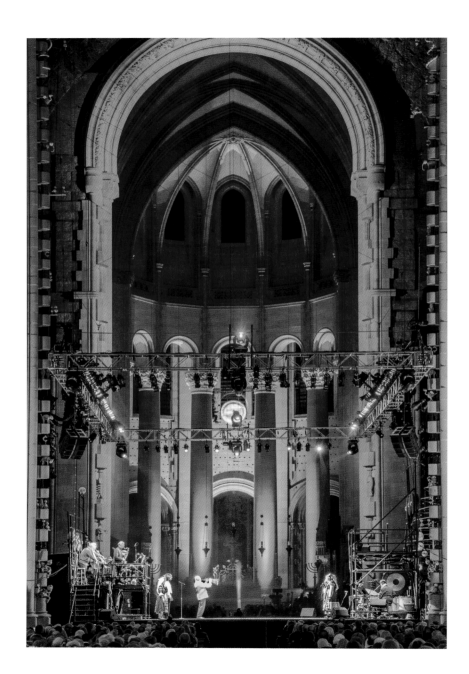

Winter Solstice Celebration. Every mid-December since 1980, Paul Winter's multi-media extravaganza of music and dance celebrates the Winter Solstice and the new celestial year at the Cathedral of St. John the Divine on the Upper West Side. Pictured are the Forces of Nature Dance Theatre, the Solstice Tree of Sounds, and the illuminated cathedral following the symbolic return of the sun. Other Christmastime events at the largest church building in the world include organ concerts and a New Year's Eve Concert for Peace.

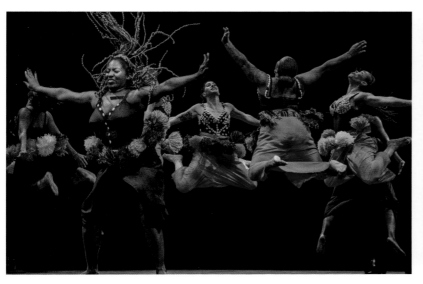
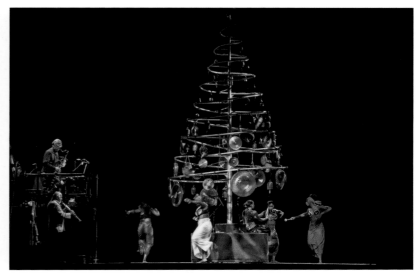

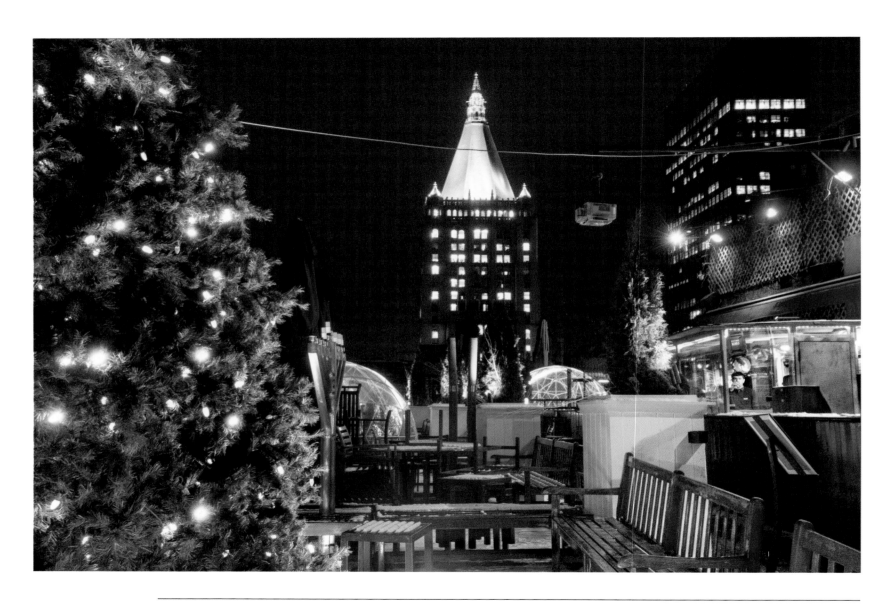

230 Fifth Rooftop Bar. One of the largest rooftop bars in the city on 27th Street is lit in fluorescent colors and offers panoramic city views. Heat lamps and inflatable igloos make the terrace rooftop a popular winter venue. One can also be warm in the 8,000-square-foot indoor penthouse cocktail lounge below.

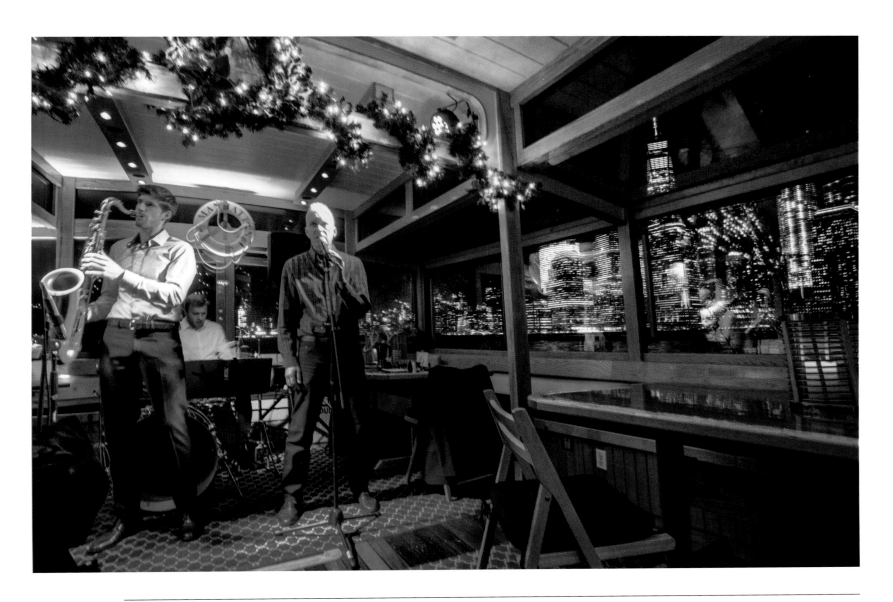

Cocoa and Carols Cruise. Classic Harbor Line offers a tour on an intimate and comfortable boat decorated for the holidays, with a jazz trio, caroling, and hot cocoa. It is one of many Christmastime cruises of varied sizes and prices that provide entertainment, wine, and stunning views of the Manhattan skyline and Statue of Liberty.

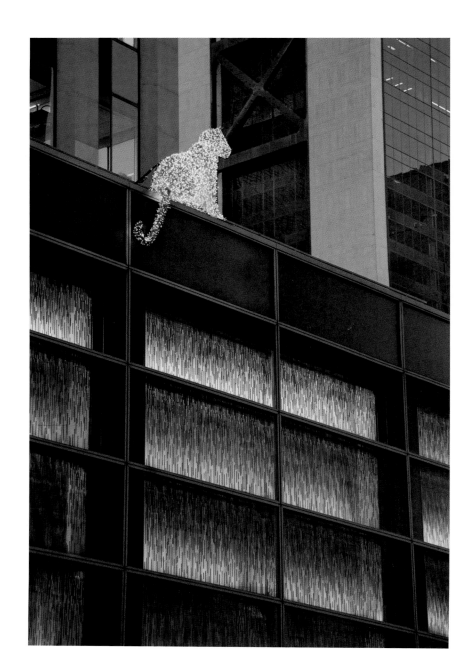

Heralding the New Year. New Year's Eve is a time of elegant, festive attire in New York. The panther motif, which adorns many of Cartier's collections of jewelry and watches, is replicated in lights to scale the buildings and sit on ledges of the Fifth Avenue Cartier stores.

160

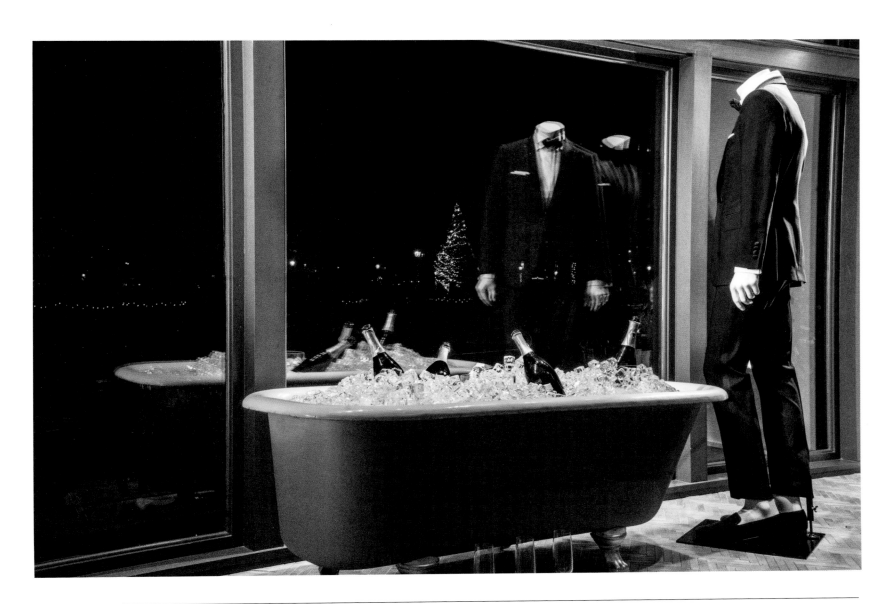

In the Todd Snyder store of modern menswear designs, a well-tailored gentleman mannequin looks toward the Christmas tree in Madison Square Park. He stands by a tub of champagne in ice, ready to salute the New Year.

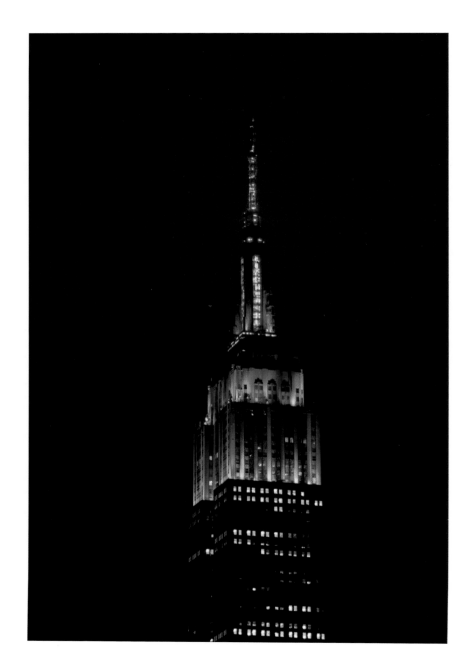

Empire State Building. The tower of the iconic 102-story building is illuminated on New Year's Eve with a dazzling display of multi-color lights designed by noted lighting designer Marc Brickman.

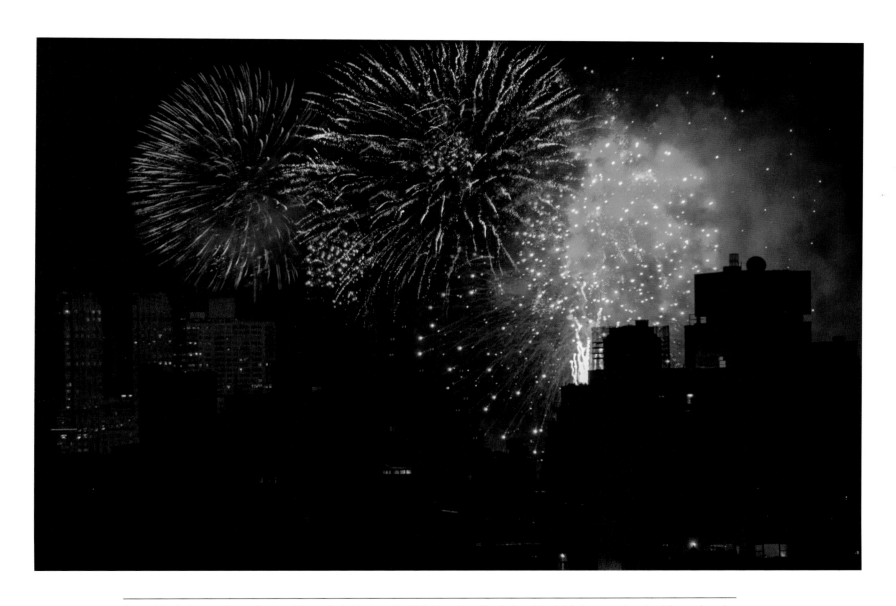

Central Park. A magnificent display of fireworks is blasted at midnight on New Year's Eve; it is visible from most parts of the park and thousands of windows that surround it.

"One of the beauties of the holidays in New York is that all nations participate in the celebration; traditions of all kinds are welcome in the revelry. The glistening trees embrace the city, a shared stronghold of enduring nature everywhere, with bells and songs raising spirits in the hope and joy of the season. New York has something for everyone, attracting millions of visitors to enjoy the many cultural facets of our urban world of multi civilizations."

Emily K. Rafferty
Chairman, NYC & Company; President Emerita,
The Metropolitan Museum of Art

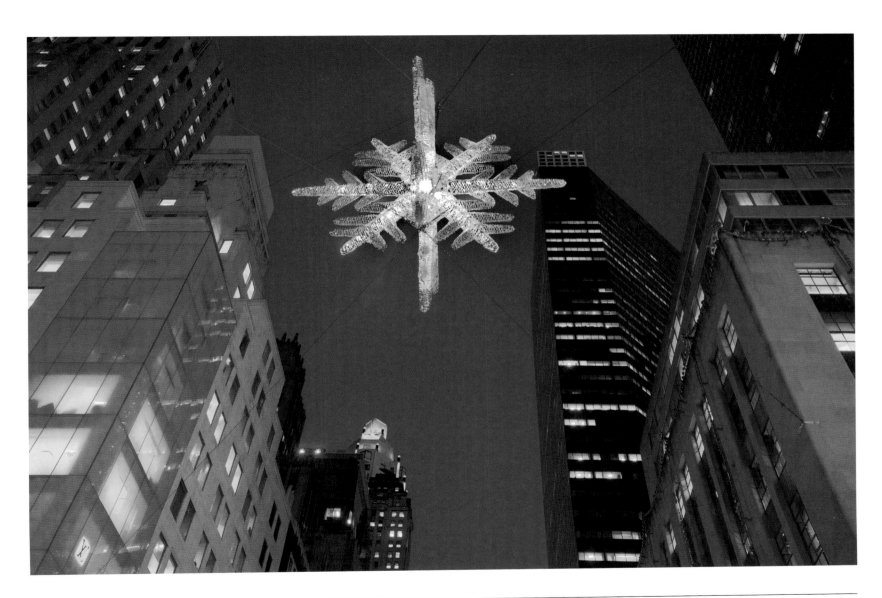

UNICEF Snowflake. The twenty-eight-foot illuminated ornament hangs at the intersection of Fifth Avenue at 57th Street as a beacon of hope to the world's most vulnerable children. It was created by noted lighting designer Ingo Maurer with 16,000 hand-cut Baccarat crystals.

Index and Locations

167

Acknowledgments

My special thanks to Schiffer Publishing, Ltd. for their confidence in my work and this book, and to my editor, Cheryl Weber. How grateful I am to James Barron for generously contributing the foreword to this book, and to all those who provided personal, meaningful quotes. I especially appreciate my longtime friends, Malcolm Spaull and Elaine Peterson, and my new friend Trudy Schlachter, for offering their professional artistic eye. I'm very grateful to those who made valuable connections and offered their talents on my behalf – Hugues de Pins, Mike Gould, Hugh Hildesley, Paula Lawrence, Barbara McLaughlin, Mary Jane Pool, Gary Delaverson, Chris Stromee, Paulette Tavormina, and Annie Smith. I couldn't have made it through the project without the assistance of Annie Vollenbroek, who I thank for her organizational skill, flexibility, and an ever-cheerful smile; and Steven Brown for his technical skill and generous spirit. My appreciation to Ruth Abraham for her professional work that inspired the charming and elegant design for this book.

Above all, my gratitude to my husband, Edward Schiff, for his unwavering support, counsel, and love.

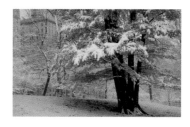

A Silver Maple tree in Central Park.

BETSY PINOVER SCHIFF is a noted photographer of landscape architecture, gardens, and travel destinations whose images were described by the *New York Times* as "an ambrosial paean to public and private spaces." This is her fifth book that focuses on New York City. Her photographs have appeared in many other books, magazines, and calendars, and have been the subject of exhibitions in metropolitan New York and Mexico. Betsy studied photography at the International Center of Photography and the School of Visual Arts in New York, and took master workshops with photographers Jay Maisel and Sam Abell, who had a strong influence on her work. Prior to becoming a photographer, she spent 15 years managing communications for the New York Public Library and promotion for Sotheby's, and codirected a gallery in New York City.